Magers & Quinn

$10.00

Sale Art -- USE THIS ONE!

D1093284

ONE WOMAN

ONE WOMAN

JOHN BOTTE · ELICIA HO

First published in 2018 by

G Arts

600 Third Avenue

New York, NY 10016

www.gartsbooks.com

media@gartsbooks.com

First edition, 2018

Library of Congress Cataloging-in-Publication data is available from the publisher.

Editor/Project Development: Joan Brookbank/Joan Brookbank Projects

Hardcover edition

ISBN: 978-0-9987474-7-7

Printed and bound in China

10 9 8 7 6 5 4 3 2 1

To our mothers—where every story begins...

PART ONE: ELICIA'S STORY

What was intended as a brief and informal lens test marked the beginning of the creative collaboration between John and me. John spontaneously lit me with a 15-watt desk lamp, and in the few moments I spent in front of his camera, I found myself shed of insecurities. In a silent exchange, we established a clear channel of communication. I felt understood and acknowledged via his lens, and trusted that together, our vision was one and the same. He was able to interpret the nuances of my emotions with accuracy, and bring them to life through his perceptive eye and the artistry within his composition. This experience was not only a revelation for me; it also served as the genesis of our photographic essay.

The portrait you see here is the result of that session. It is just one version of me and the beginning of the photographic exploration of who and what has impacted my experience as a woman. This project came from the desire to create a visual diary of my becoming by portraying the individuals and archetypes—whether real, fictional, or historical—who have influenced, inspired, and shaped my life. We are many people, and what resonates with us changes throughout our lives.

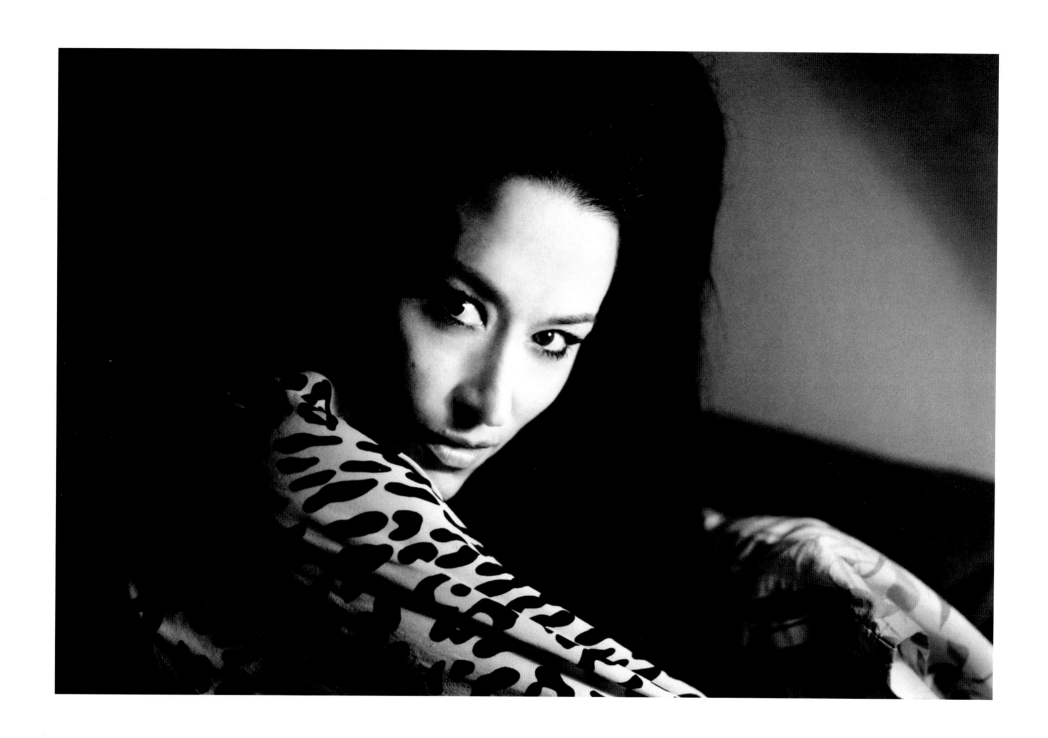

Via formal portraiture, I wish to depict one simple and often overlooked truth. Each of us has an impact, leaves an imprint, and in turn, affects every person with whom we have contact, sometimes even having an impact beyond our immediate reality. One does not need to be famous to be influential. We can live an ordinary life, yet have the most extraordinary influence on one another. Whether we are conscious of it or not, each of us exercises that power, and that power is ours to determine the qualities that we wish to contribute. *One Woman* visually represents the idea that we are all interconnected and obliged to influence one another's story.

SHANGHAI AUNTIES My father was born in Shanghai, China, in the early 1930s. He emigrated to the United States as an adult and lived out the second half of his life in America.

As is true for so many born in this country, my ethnicity has roots elsewhere. I am half Asian and half Caucasian. This is the alchemy that created the American girl that I am. I am of this place and of another. And in keeping with this paradox, my Chinese heritage is both familiar and elusive. I do not understand or speak the language, yet I feel a strong connection to my Chinese family, their customs, and their culture.

This photograph represents my wonderful and beautiful Chinese aunties, Greta, Angela, and Eve. They are the gateway, the guideposts, and the touchstones to my Chinese heritage. They are my bridge to the other side of the world, the conduit to understanding Chinese traditions, and most importantly, the interpreters and the guardians of my father's family history and their memories.

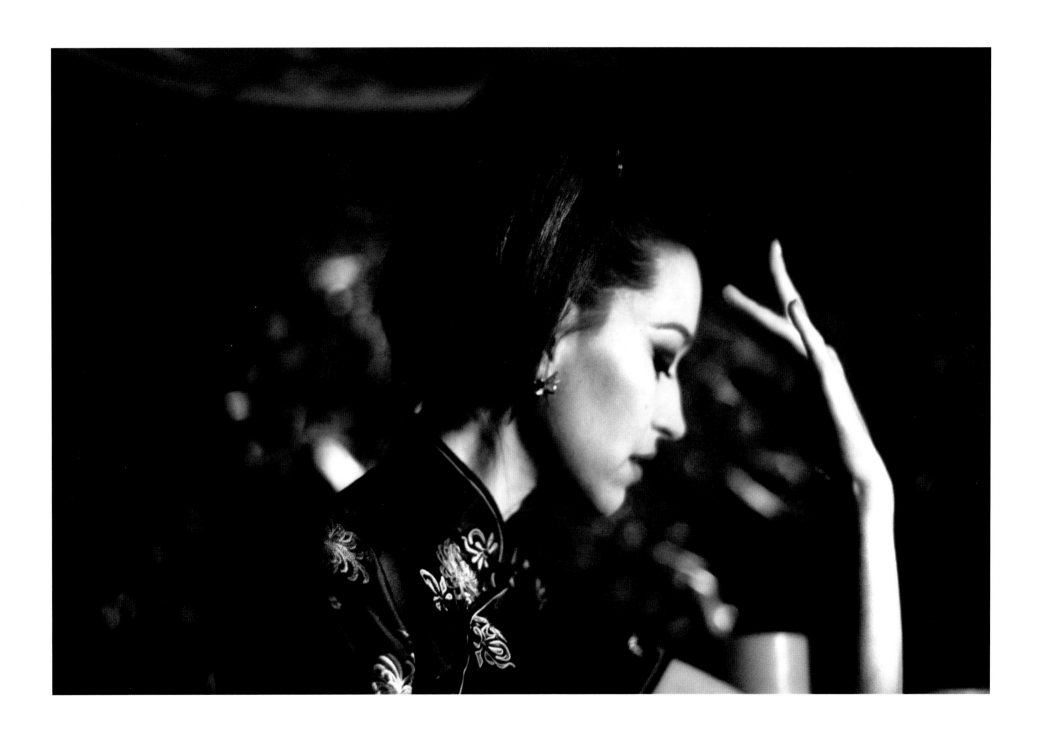

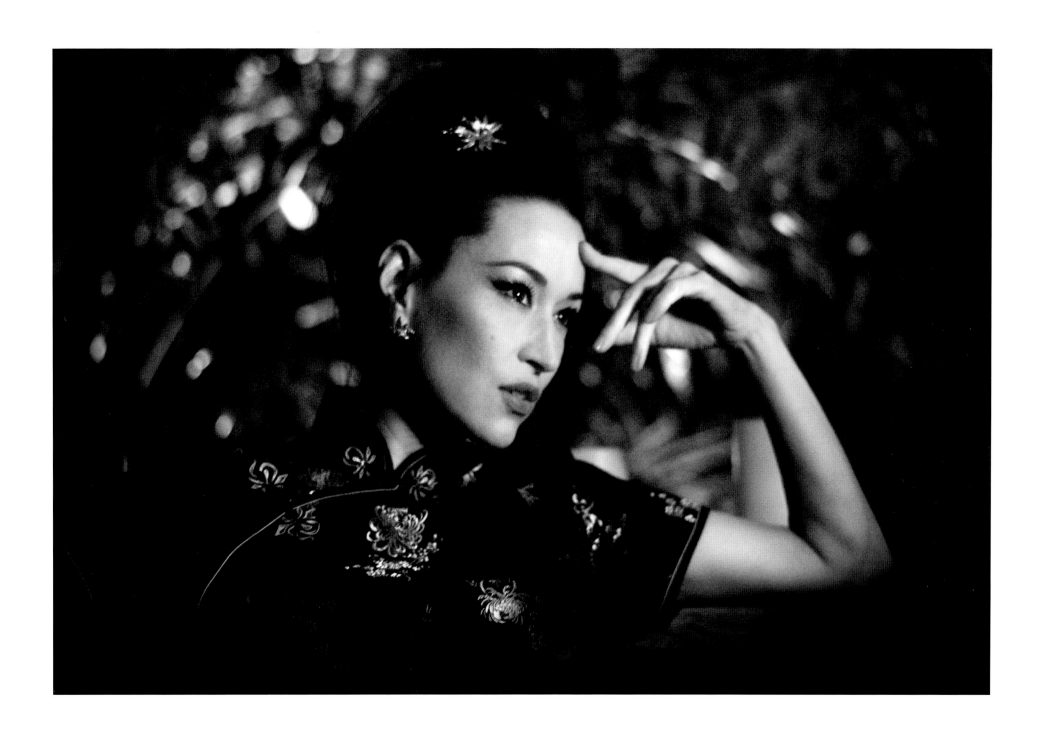

JOSEPHINE BAKER I have long admired entertainer and activist Josephine Baker for her vision of a world where discrimination does not exist. She lived her life according to that vision by refusing to perform before segregated audiences. A true, self-made heroine, Josephine Baker lived as a street child in the slums of St. Louis, Missouri, and rose to become a legendary performer, a decorated agent for the French Resistance during World War II, and an important crusader for the civil rights movement. Her spirited courage instigated change and redefined our perspectives on gender and race.

As a woman of mixed ethnicity, I find that her achievements are an enduring source of inspiration. Through her artistry, convictions, and fearless self-expression, Josephine Baker was able to break through barriers and, in so doing, has propelled us toward her vision of a world without prejudice.

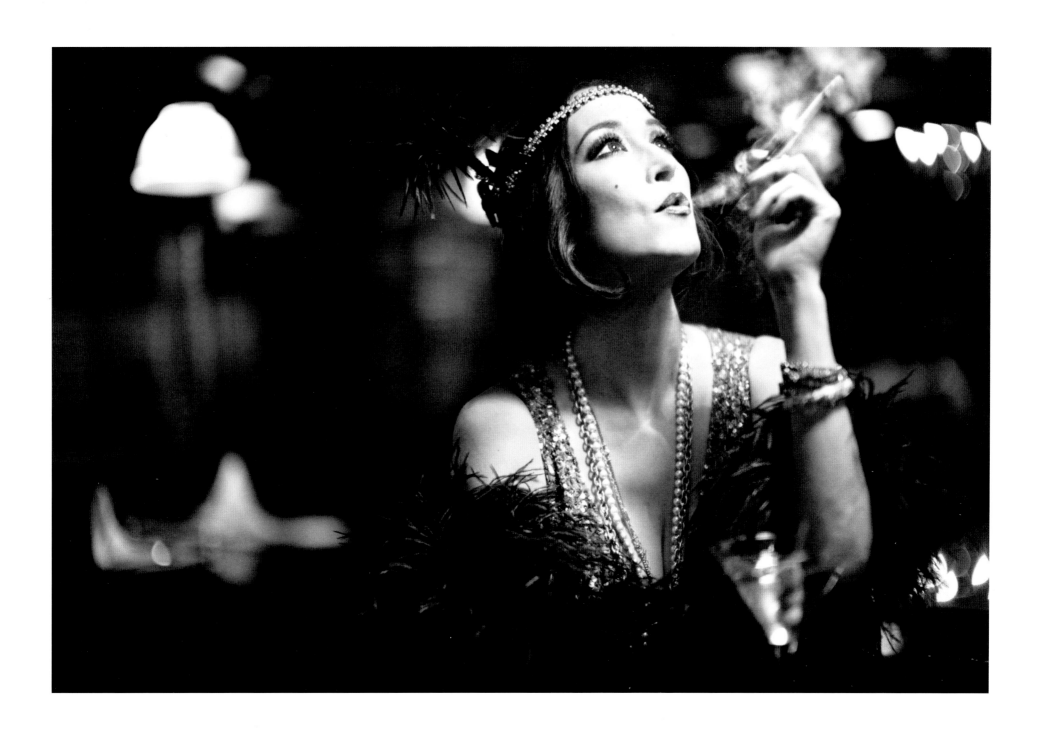

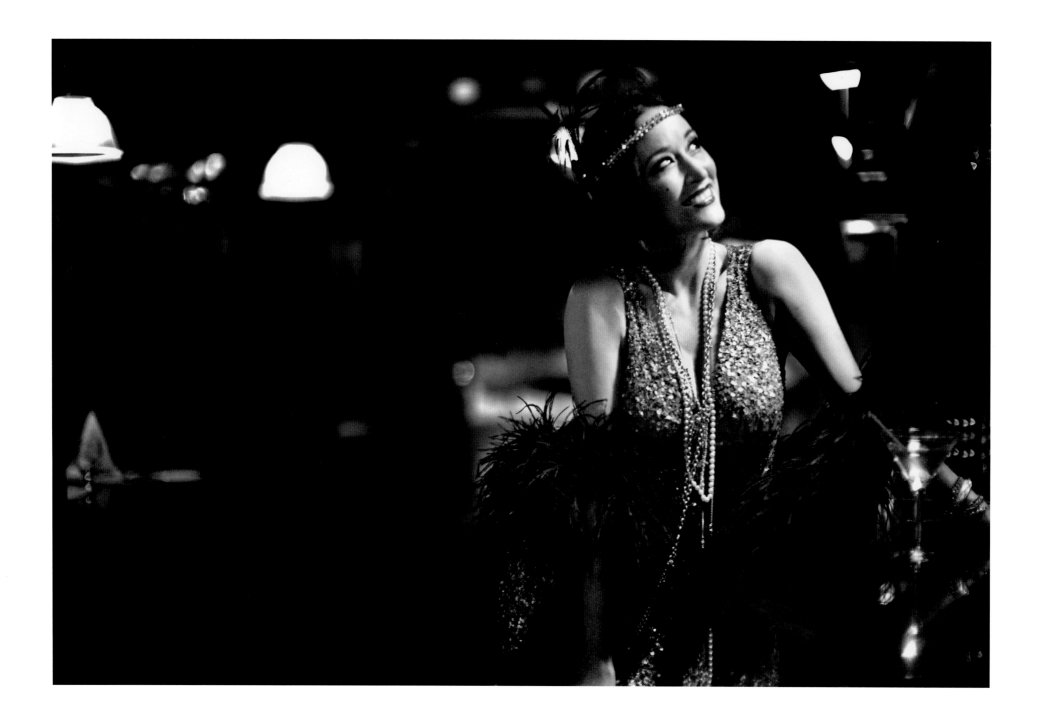

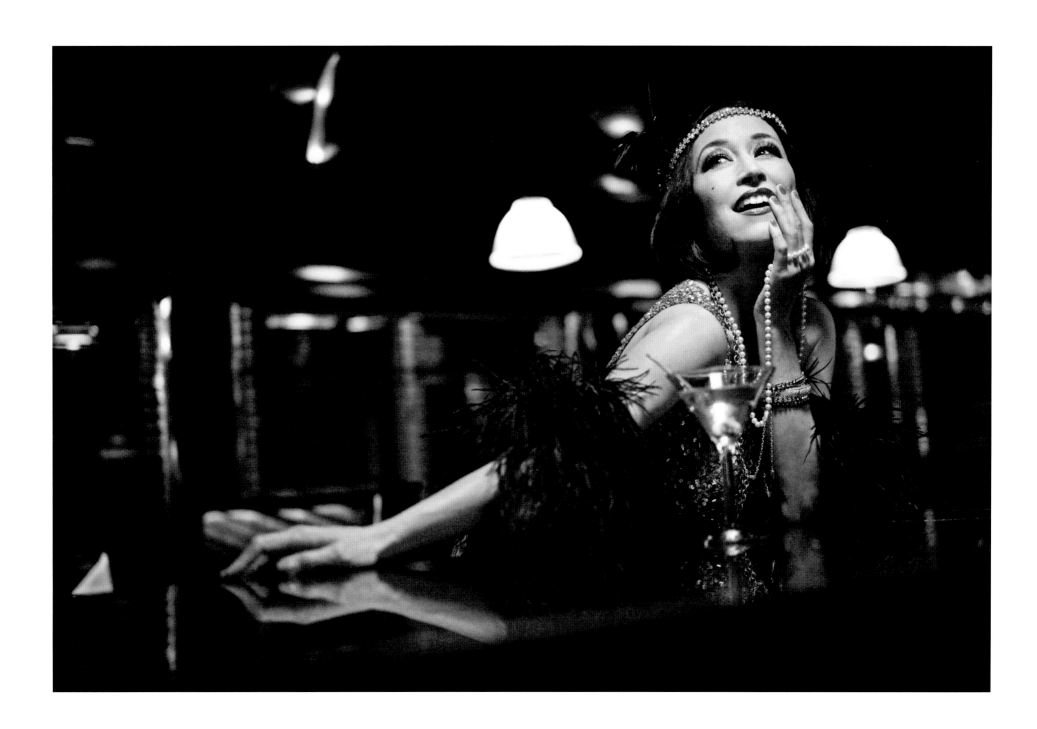

GRANDMOTHER CAROL My grandmother Carol grew up in Spokane, Washington, where she began her young adult life in a traditional marriage with two children in post–World War II America. She was not, however, designed for a life of convention. When her children were teenagers, Carol divorced her husband and went back to school to become an anthropologist. Her passion was studying American Gypsies. During her years of field work, she connected with a tribe and became one of them. I didn't see her much while I was growing up. Her chosen life was among the Gypsies. This is how I remember her during that time—dressed in skirts for Gypsy celebrations and wearing all her gold, because that, she said, was what a Gypsy wore for good luck.

I pay homage to my grandmother's free spirit that was, and still is, always tempered by her thirst for knowledge—a beautiful balance that has enriched her life with adventure and meaning.

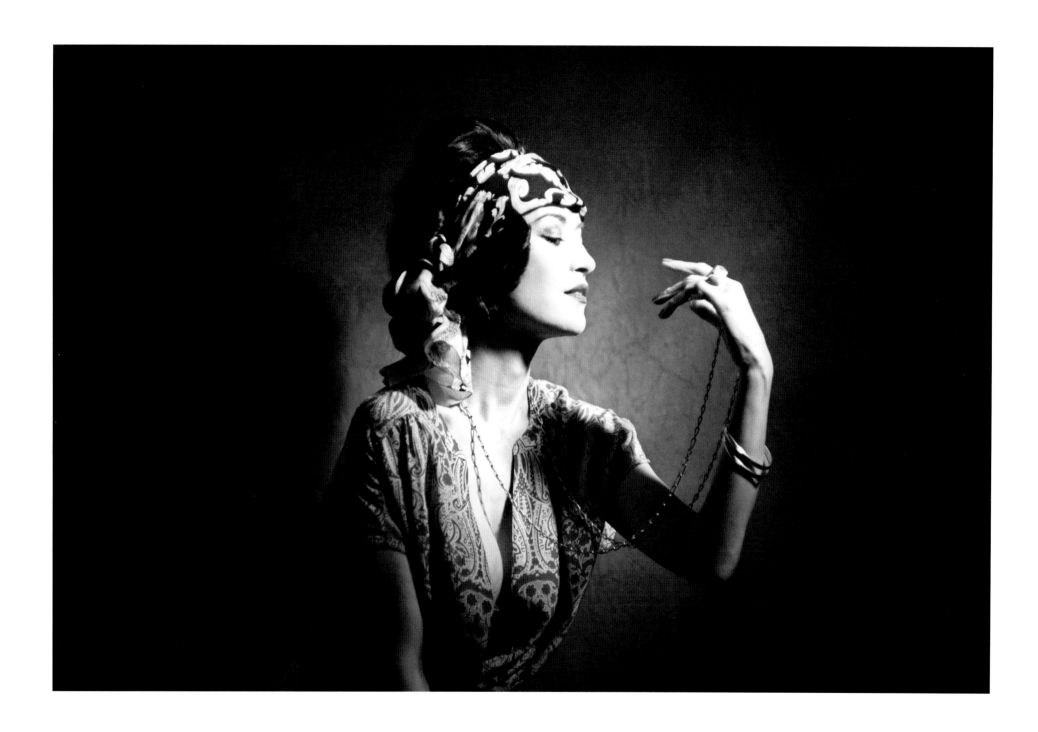

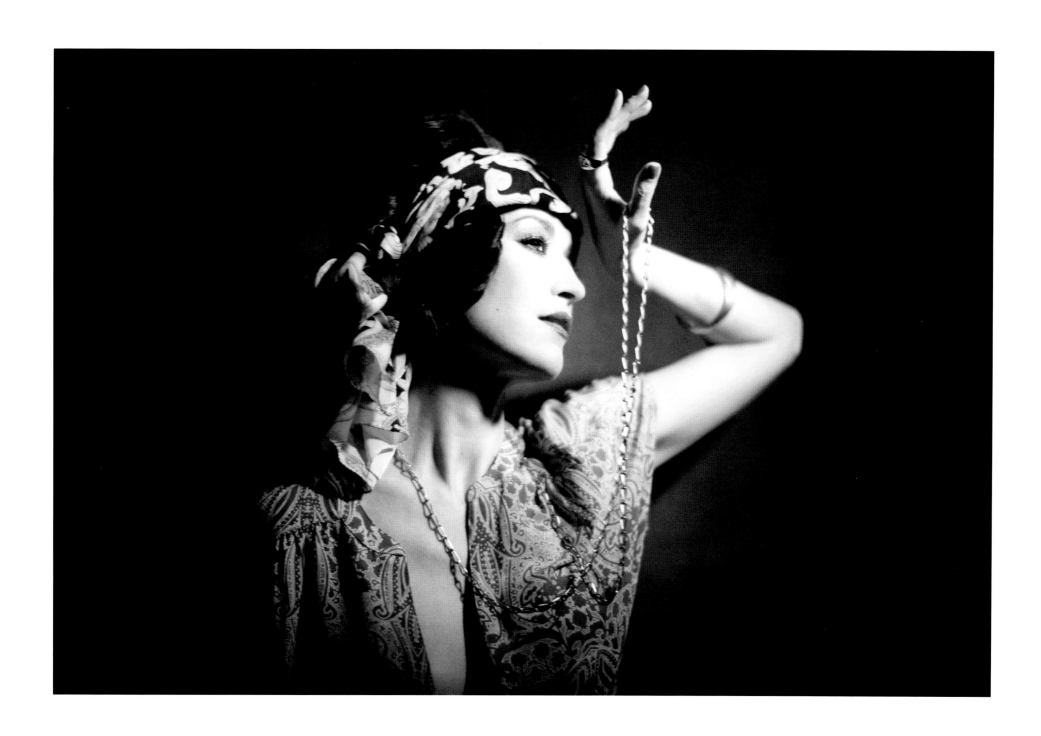

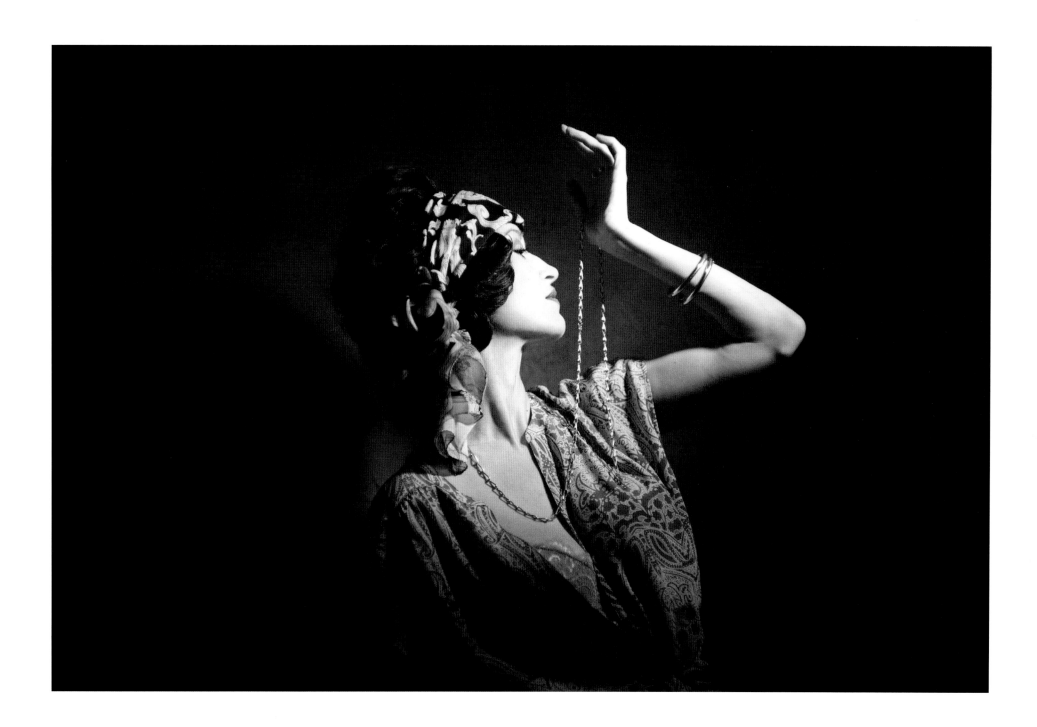

NANCY DREW I grew up during a time when women had more restrictions and limitations when pursuing a vocation. Perhaps this is why my first woman hero is the fictional amateur sleuth Nancy Drew. She is self-possessed, resourceful, proficient, and accomplished in everything she puts her mind to. Without surrendering her feminine identity, she neutralizes the paradox of a female succeeding in a man's world and does so with effortless competence. Inspiration does create reality. Consequently, Nancy Drew is a character who starts the conversation for young girls about what can be possible.

Much progress has been made since I was a young girl, and I anticipate the trajectories of future heroines. Whether our heroines are actual persons or fictional characters, they are inevitably women with smarts, skills, intuitiveness, ingenuity, and most admirably, audacity.

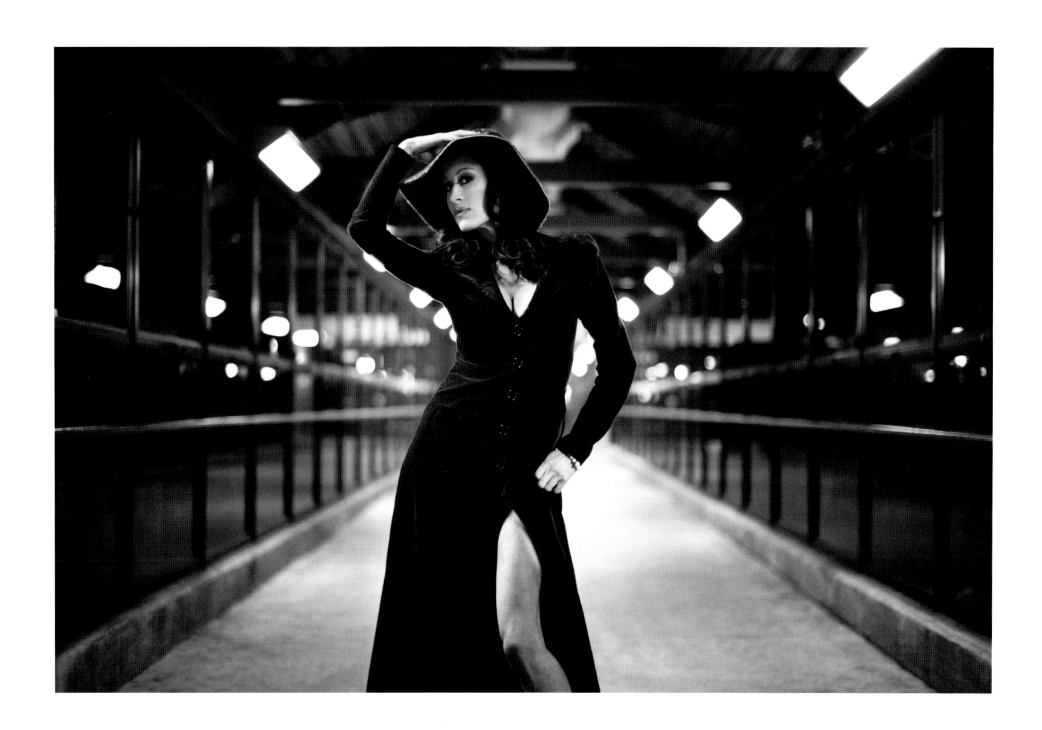

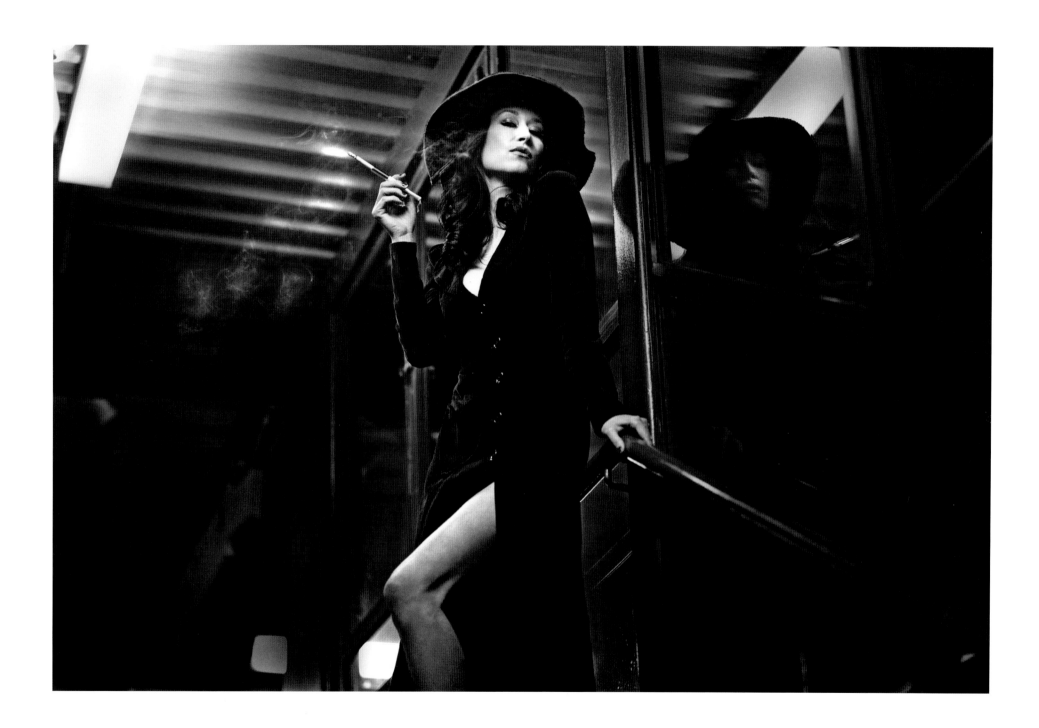

VERUSCHKA Prussian-born Countess Vera Gottliebe Anna Gräfin von Lehndorff-Steinort is a 1960s style icon, model, actress, and artist known professionally as Veruschka. In photographs she is both austerely composed and naturally exotic. Visually she has the ability to transform the contrived into a mystical experience. Veruschka is a consummate conceptual artist: she uses modeling as a medium to communicate and translate the mood of a given assignment.

This is especially evident in her collaboration with photographer and painter Holger Trülzsch in the 1986 published book *Veruschka: Trans-Figurations* in which she seamlessly blends into various environments within nature and man-made settings. The mistress of dichotomy, she reveals her identity while simultaneously disappearing and becoming one with all that is around her. A model and muse, Veruschka takes us beyond a beautiful photograph and into the realms of high art.

From the time I was a toddler to now, I have been fascinated by the art of makeup and its ability to alter our perceptions. I have spent many hours transforming myself into different people. Conceptualizing and interpreting personalities has always been an intriguing art form to me. I appreciate Veruschka's innate talent and will always view her as an exceptional instrument of beauty and artistry combined.

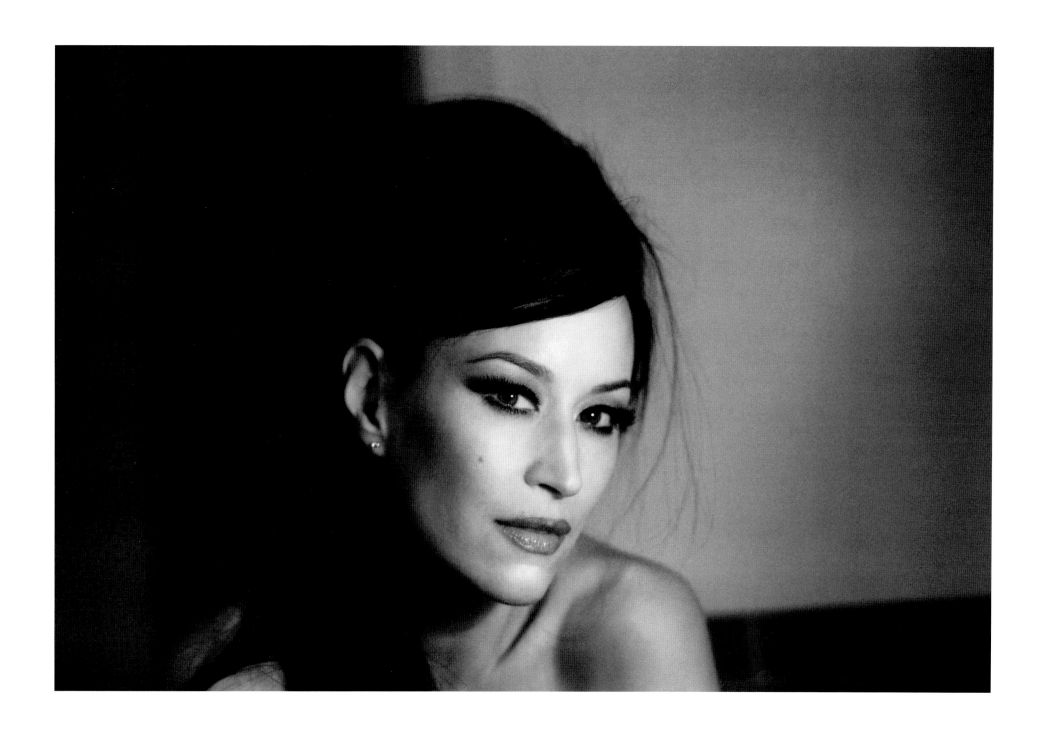

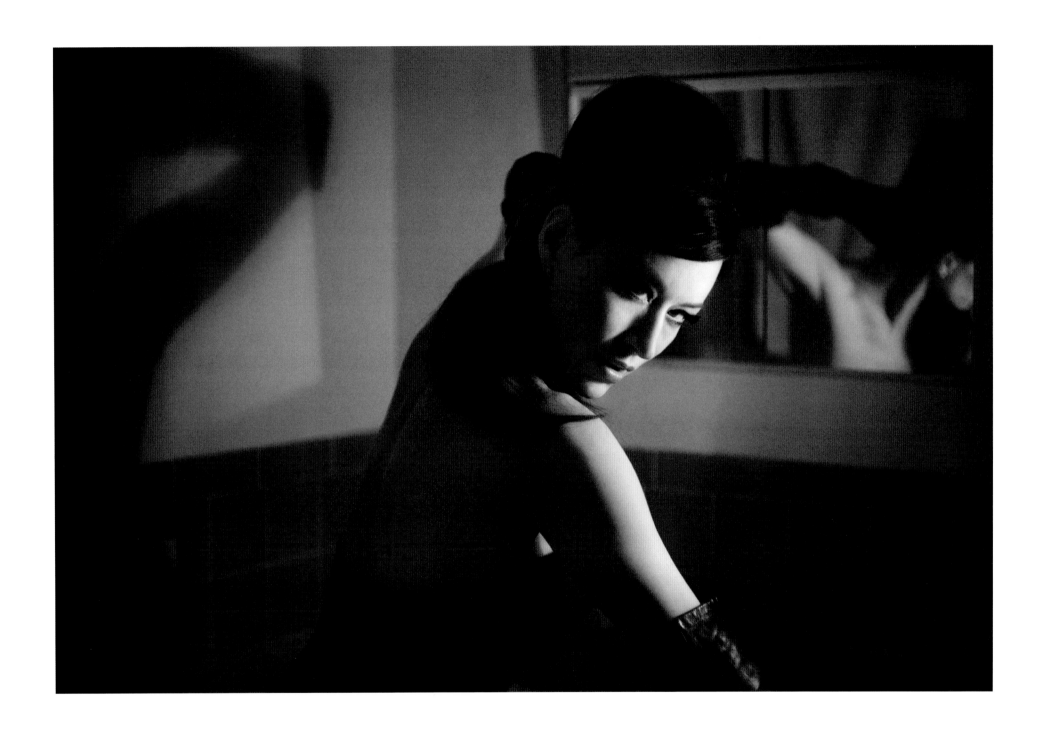

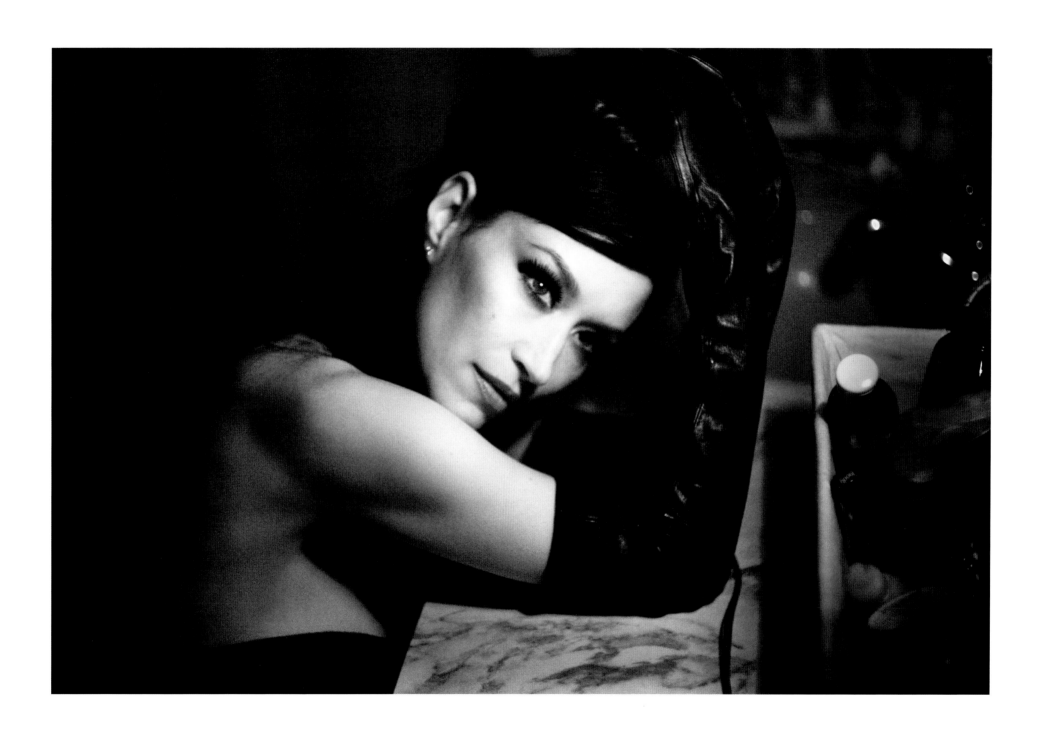

THE BALANCHINE BALLERINA This is my homage to George Balanchine's ballerinas. They are like mythical goddesses to me. Each dancer possessed her own authentic power and style, and each was vividly individual in the way she expressed and communicated Balanchine's choreography. As a young girl, I would often purchase a standing-room-only ticket in the fourth ring at the New York State Theater. I was high up and far from the stage, but that did not keep the magic from reaching me. On one occasion, Suzanne Farrell was performing. There was a moment during the ballet when she simply stood still with her back to the audience. Her ability to communicate the emotions of the choreography and music while standing motionless electrified me. That's how special a Balanchine dancer was. They were otherworldly creatures, able to become an art form within the context of an art form. It was truly a profound experience to be under the spell of ballet during the Balanchine era.

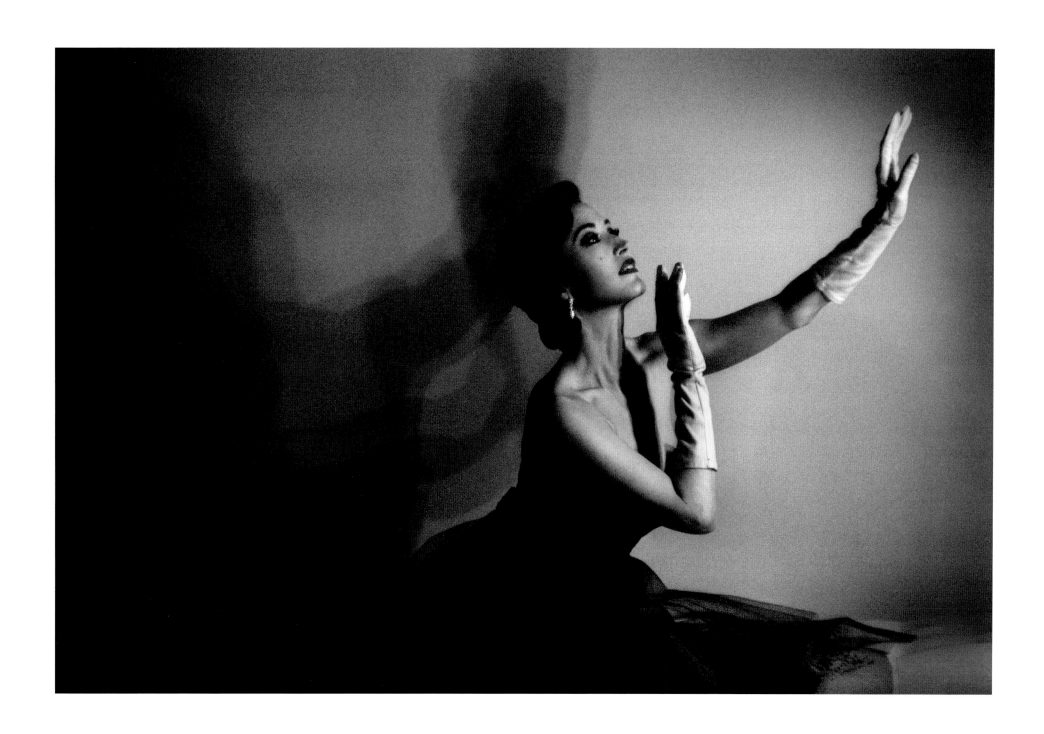

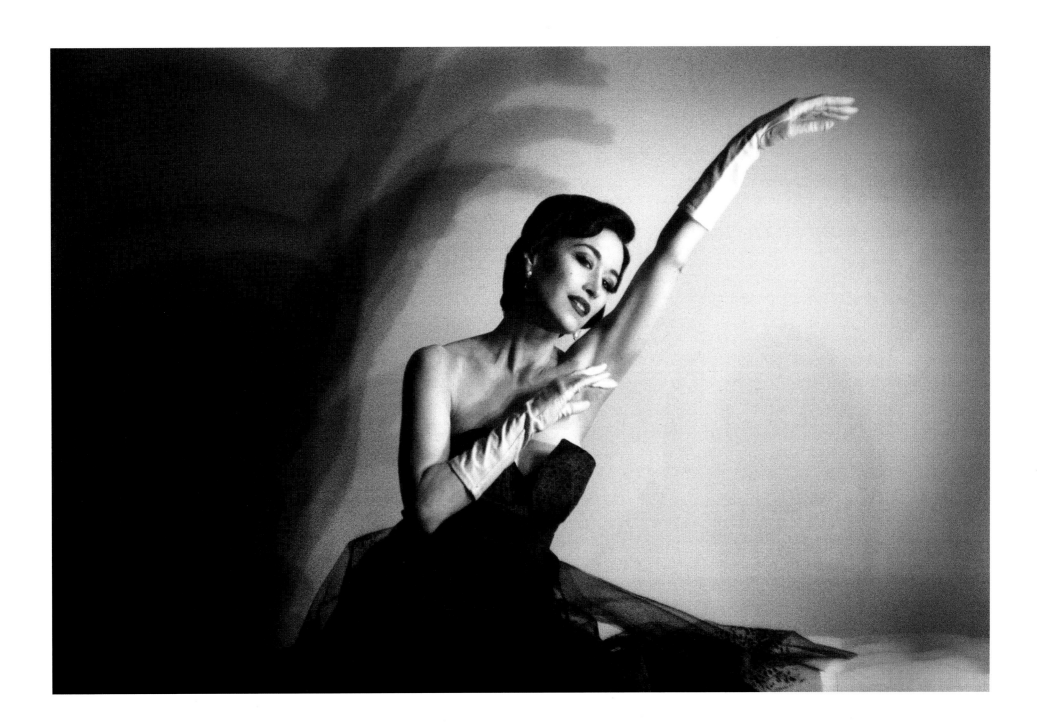

GREAT-GRANDMOTHER MYRTLE My great-grandmother Myrtle—or Mimi as we called her—was born to a homesteading family of farmers in the outskirts of Spokane, Washington. She would prove to have the makings of a true Renaissance woman, navigating her own way to the city and later coming to represent the highest standards of a middle-class housewife. Mimi was elegant, fastidious, proud, and never without pearls in her earlobes. Looking at her, one would never suspect that beneath her perfect poise was a salt-of-the-earth, astutely resourceful woman capable of forging anything with her bare hands and through her single-minded determination.

She epitomized the self-sufficient woman of her era, growing and canning her own food, sewing, knitting, and holding it all together as the matriarch of five children and four generations. In this modern age when our conveniences and needs can be met with little effort, Mimi represents a woman from a bygone era when the essentials for survival could only be materialized by the efforts of one's own hands. So as the past forges this present, I portray the elegant and utterly capable being that she was, in honor of her and women like her who possess ample strength and fortitude to inspire our own personal perseverance.

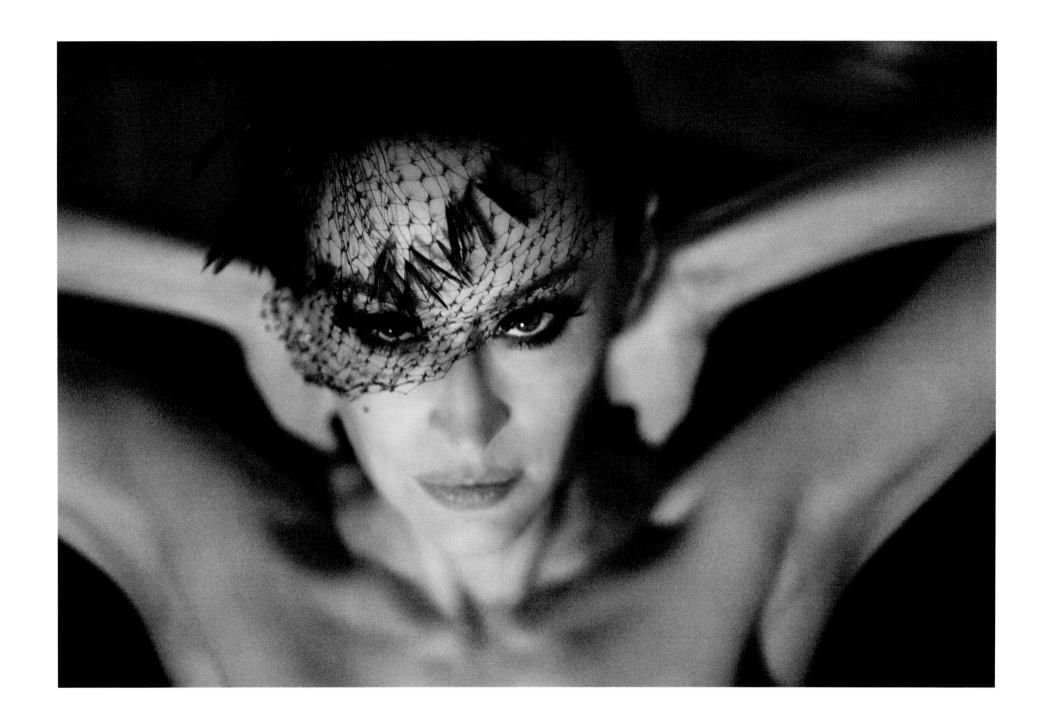

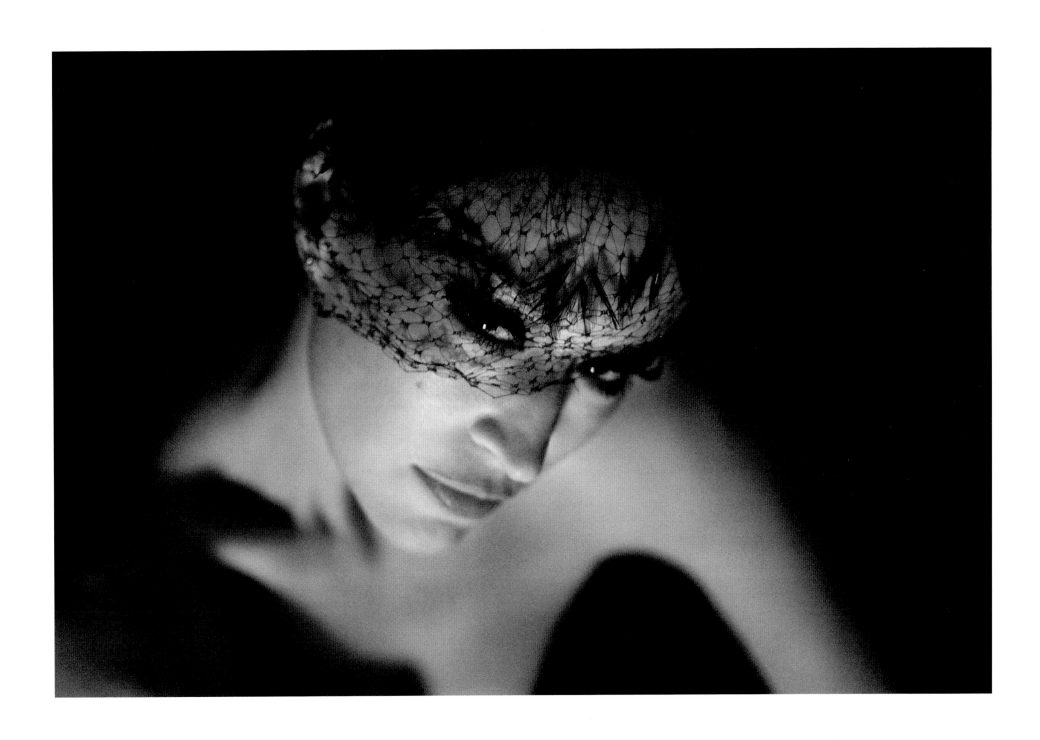

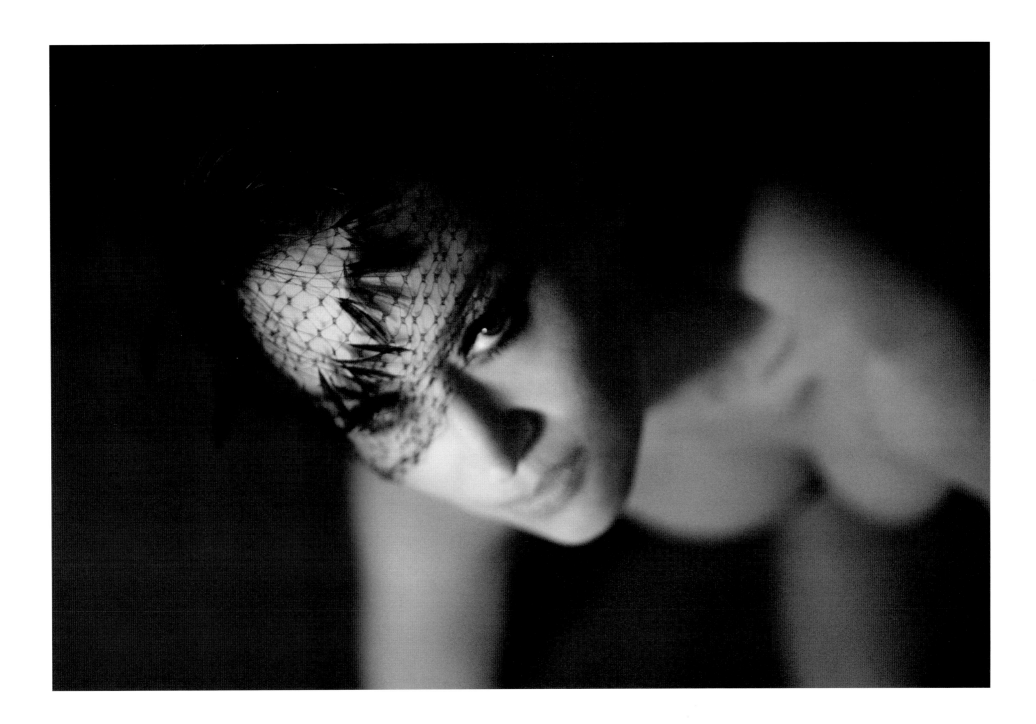

THE DIVA The diva is celebrated for her superlative talent in many genres, from music and theater, to film and fashion. She possesses an undeniable gift—communicating a truth through art's universal language. When we experience her brilliance, it accesses our souls. We feel as though we are witnesses to something divine. The partnership between her masterful technique and extemporary artistry allows her to transcend what seems earthly possible.

The diva's talents resonate deeply and can remain with us for a lifetime. For me, Maria Callas, Barbra Streisand, Natalia Makarova, Gelsey Kirkland, Aretha Franklin, Meryl Streep, and Ellen Burstyn all share the right to be called divas. Through their art, they bravely open the portal to their pure vulnerability and, in doing so, actualize an experience of astounding spiritual beauty.

The diva is the ultimate embodiment of inspiration, and it is no coincidence that "diva" derives from the Latin term for goddess.

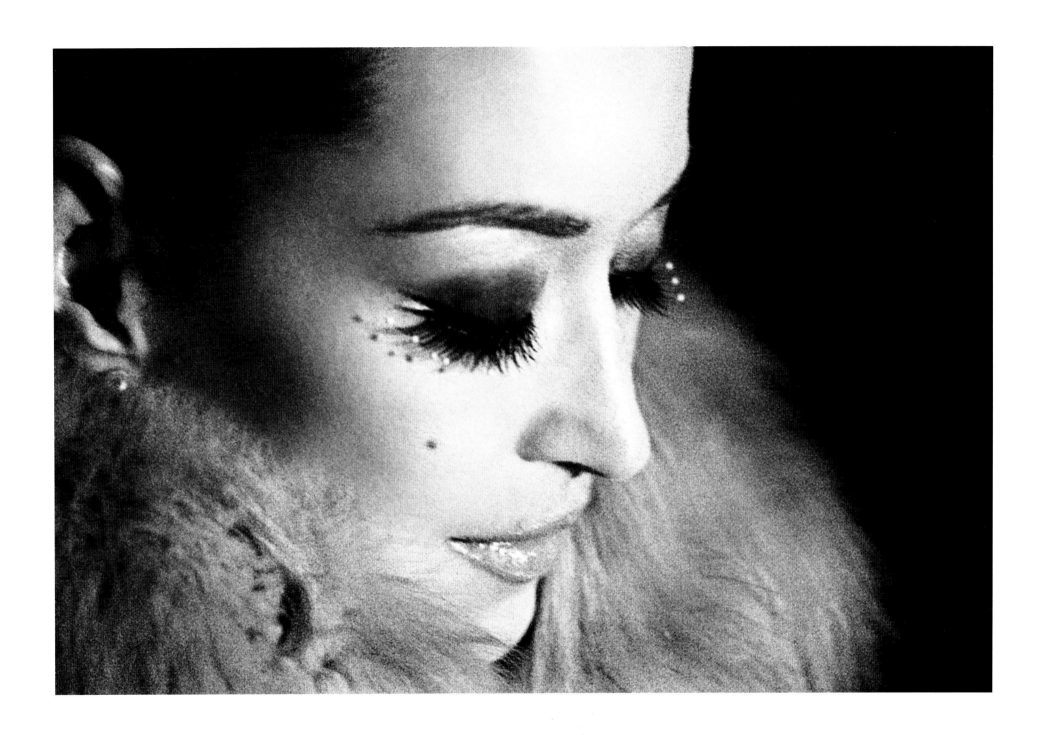

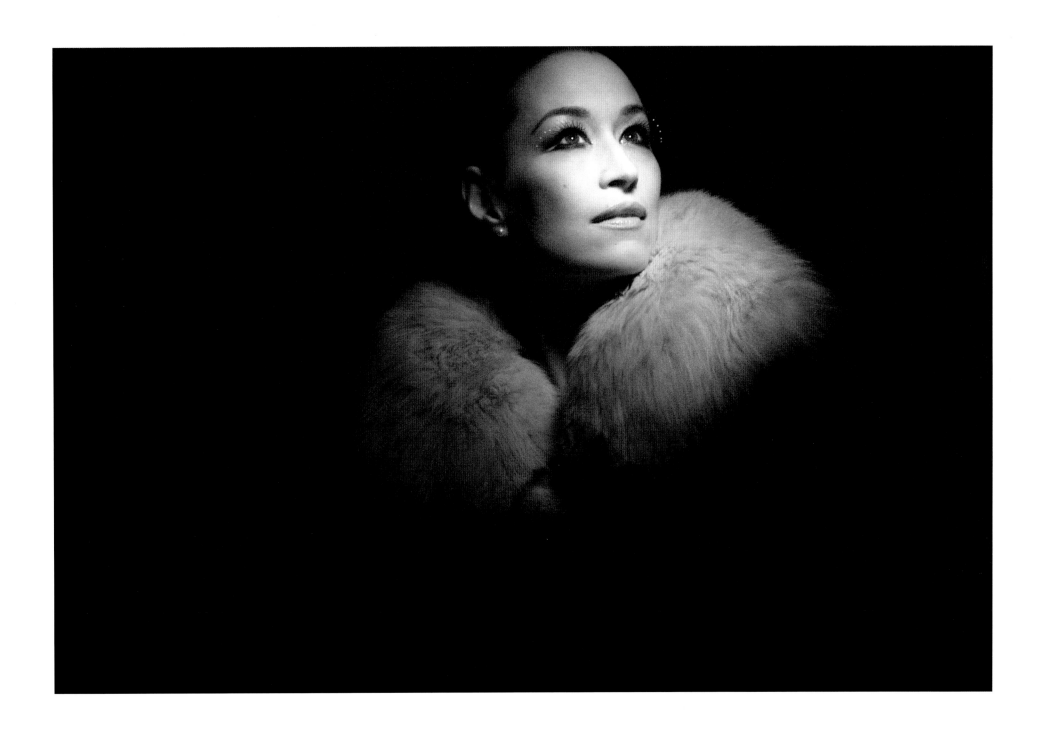

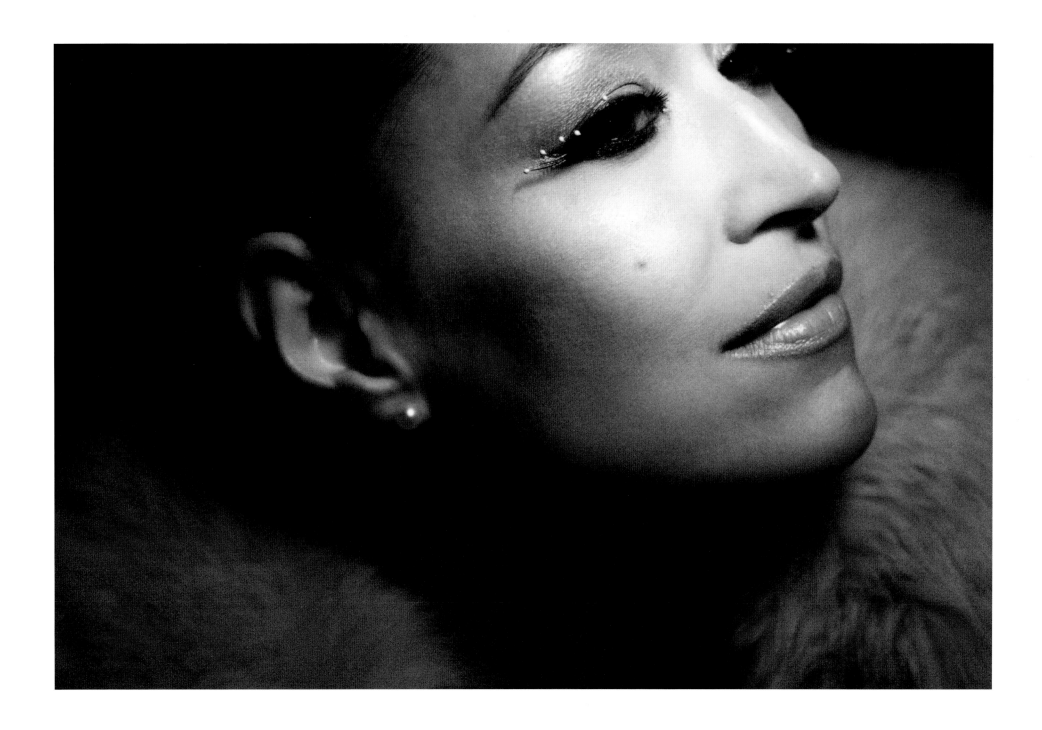

Georgia O'Keeffe Georgia O'Keeffe was an early innovator in modern American art. What moves me most about her work is that she found and followed her own creative voice and did so without inhibitions. Her unconventional paintings convey her emotional experience with a subject matter, resulting in expressive forms and colors that are at once sensual, harmonious, and simplified to the near abstract. O'Keeffe's painting style derived from an inward-looking perspective. Her poetic strokes, original angles, and essential structures clearly indicate that she had depth and confidence.

I find respite in her flower series, especially *Abstraction White Rose*. Within its circular maze I experience both the flower and the artist as being at one with themselves and with all matter and existence. It is an intimate statement of harmony and equanimity.

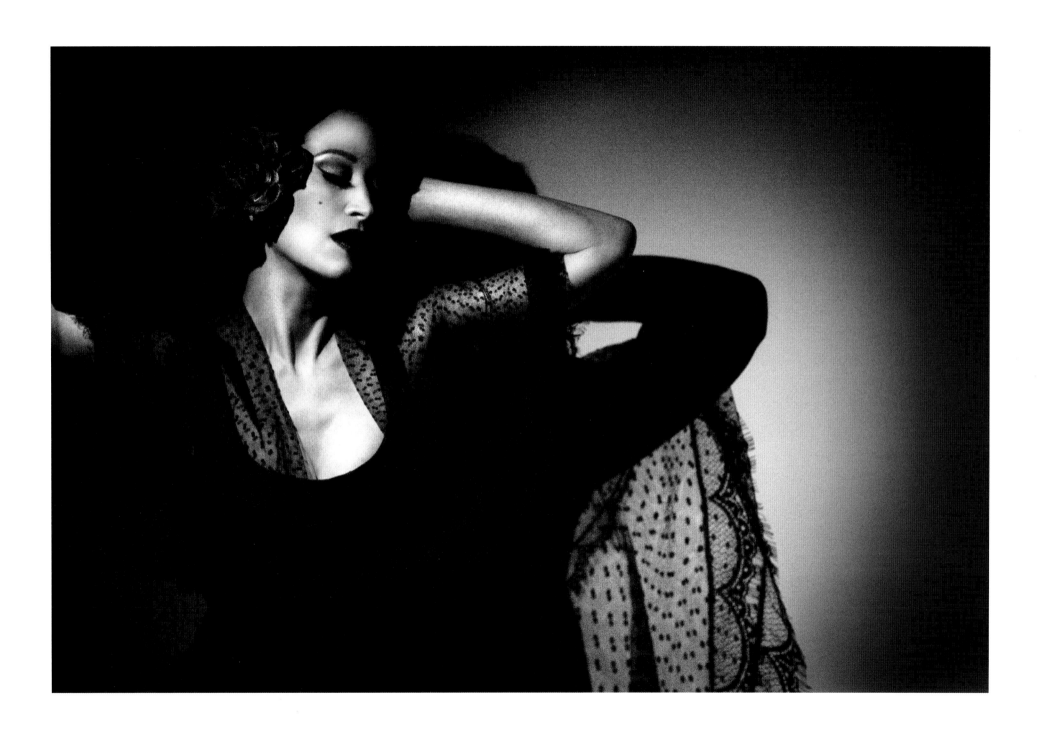

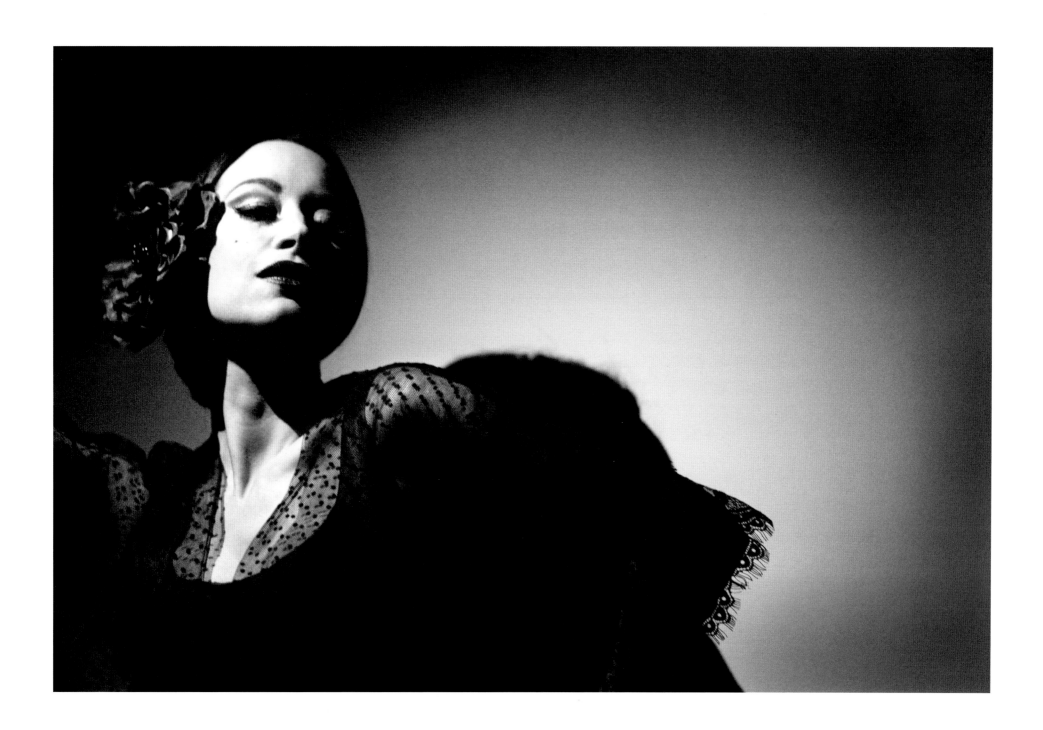

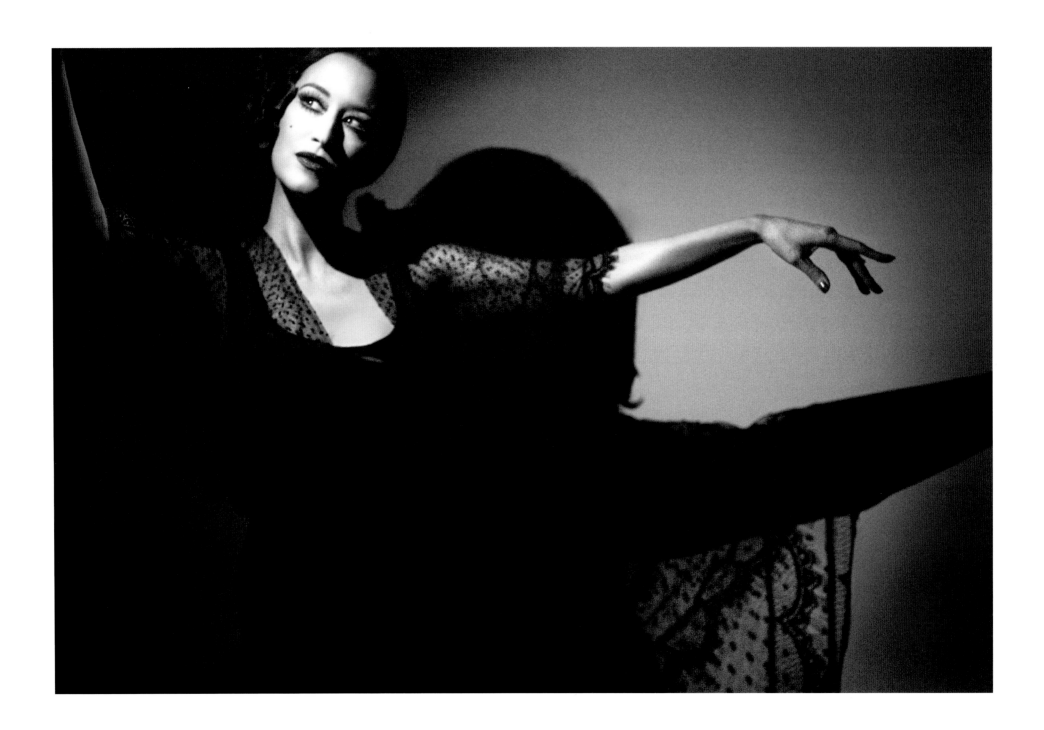

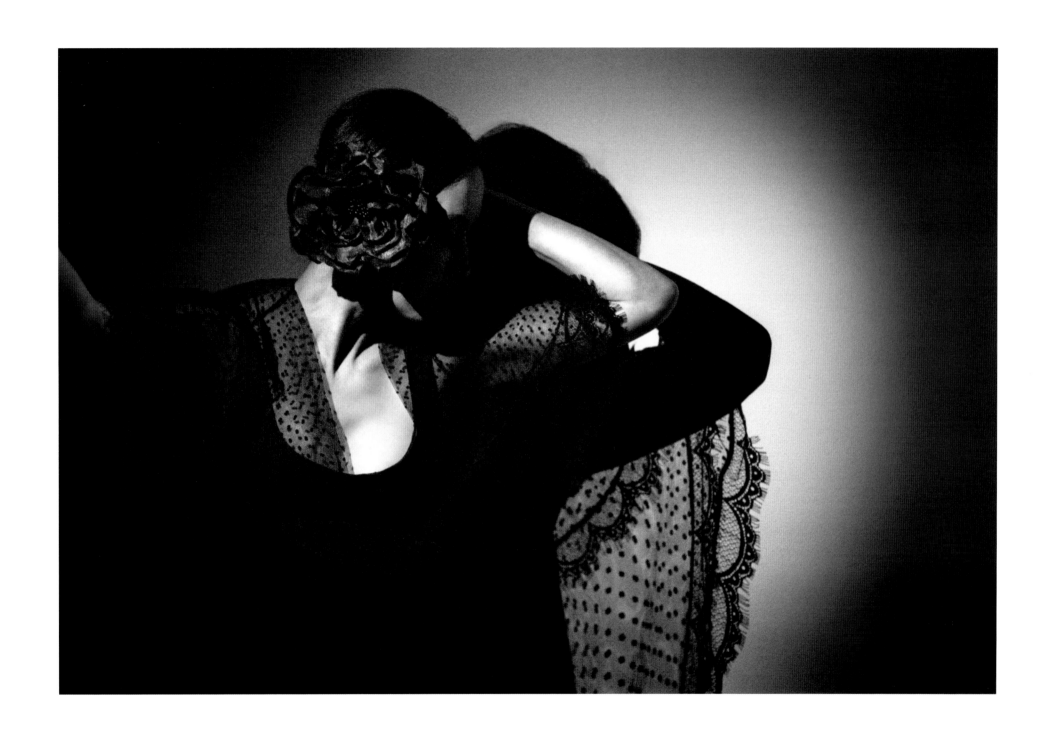

THE HOLLYWOOD SIREN The Hollywood golden age gave us the silver-screen siren—an astonishing beauty with a dazzling wit. She is all woman and knows just how to be one. The siren is absolutely unattainable, mainly because she is not real. Even so, her perfection enchants me.

The real world's unpredictable storyline is perhaps what makes the heroine and her happy ending so seductive. I am especially transported and hypnotized by the glamorous, self-possessed characters who are adept at wielding a wry sense of humor. Lauren Bacall, Katharine Hepburn, Veronica Lake, and Rosalind Russell particularly capture my admiration.

Whether they are delivering that come-hither look or flashing their sharp comedic banter, they are magic on screen, and I am absolutely captivated.

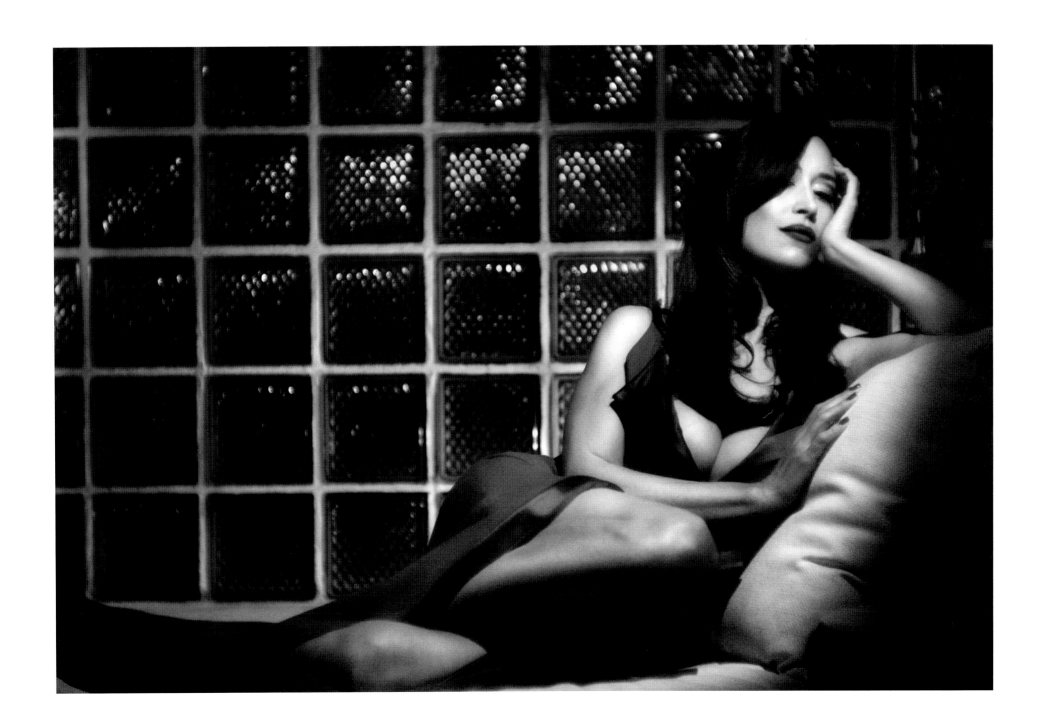

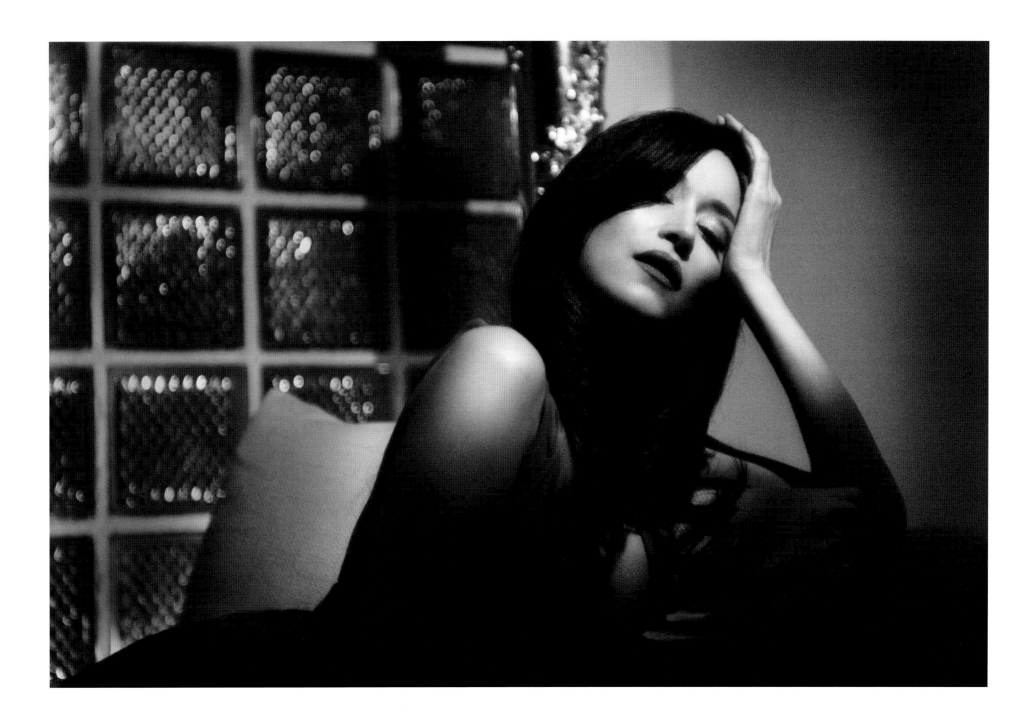

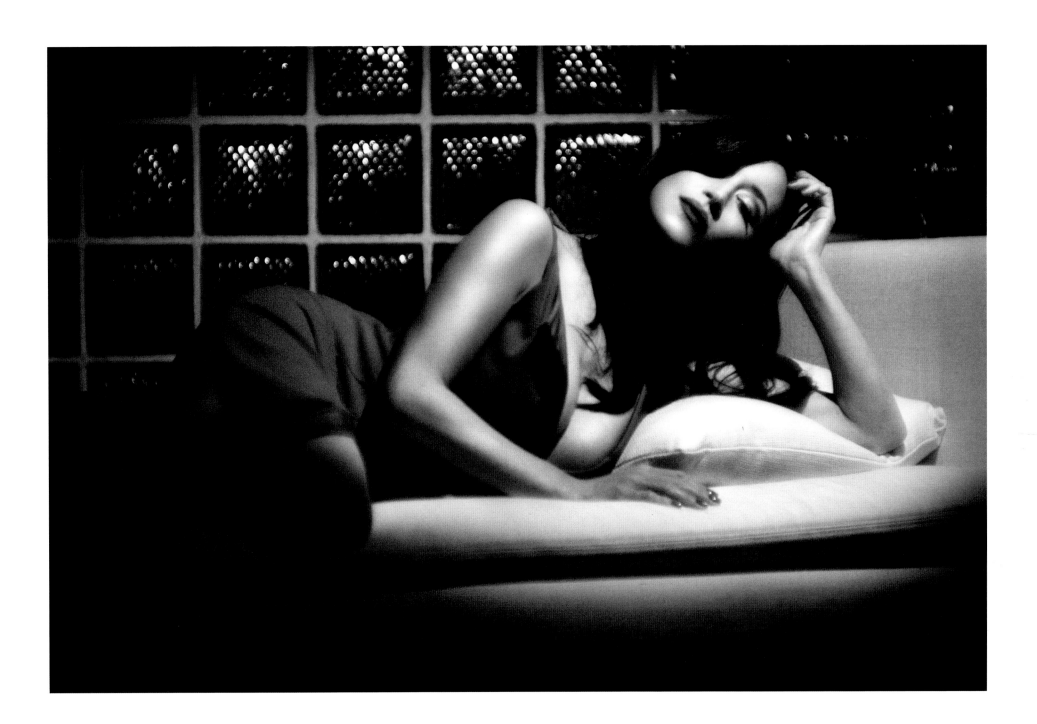

THE MASCULINE FEMININE My father was my first feminist role model. He was a modern man, despite coming from a culture with very specific roles for men and women. He held a male-only position in the company he worked for and advocated for his female coworkers to have the right to be considered for his job. His genuine belief in unbiased treatment motivated this act, a conviction that translated into my own upbringing. There were never limitations imposed upon me for being born a girl, and I felt I had his support in any endeavor I chose.

There are women in my life, and everywhere, who experience limitations and defy them. Like aviator Amelia Earhart or Nobel Prize-winning scientist Marie Curie, these women break from the status quo and pursue callings in traditionally male professions. Like my father, they also show me that boundaries can be overcome. When it comes to their life choices, they aren't afraid to fulfill their passions. Although I personally do not possess the desire to become an attorney, or a doctor, or run for political office, knowing such women instills enough confidence within me to risk pursuing my own aspirations.

Being true to oneself is a heroic undertaking. As our roles are being integrated at home and in the workforce, my hope is that it brings us to a deeper understanding within ourselves and between one another, regardless of gender.

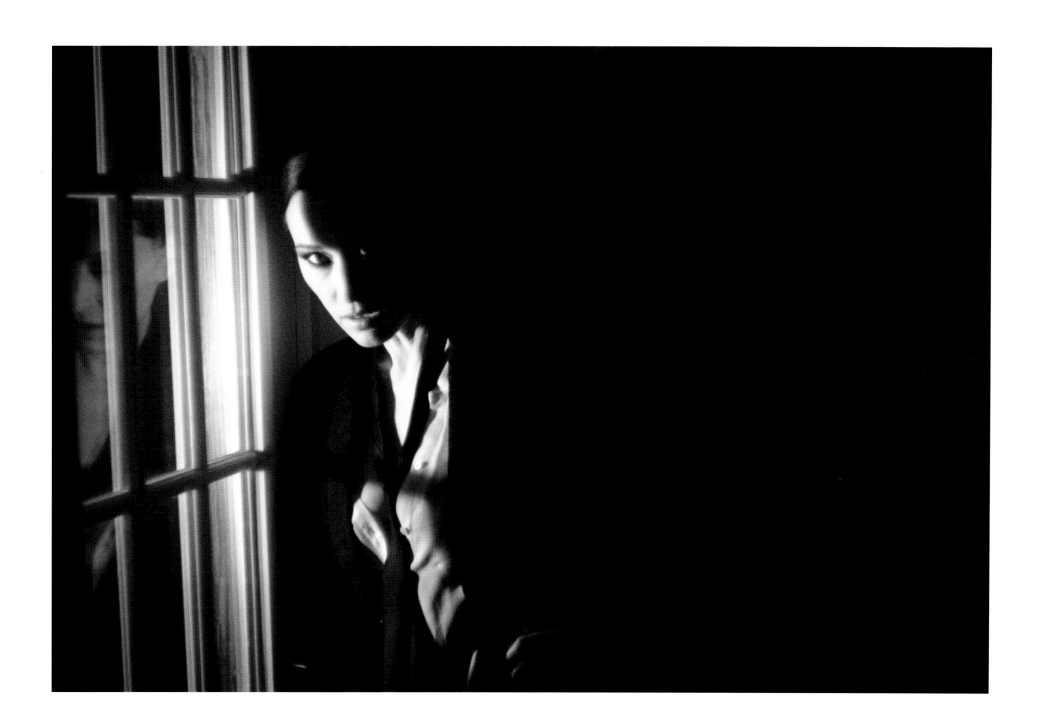

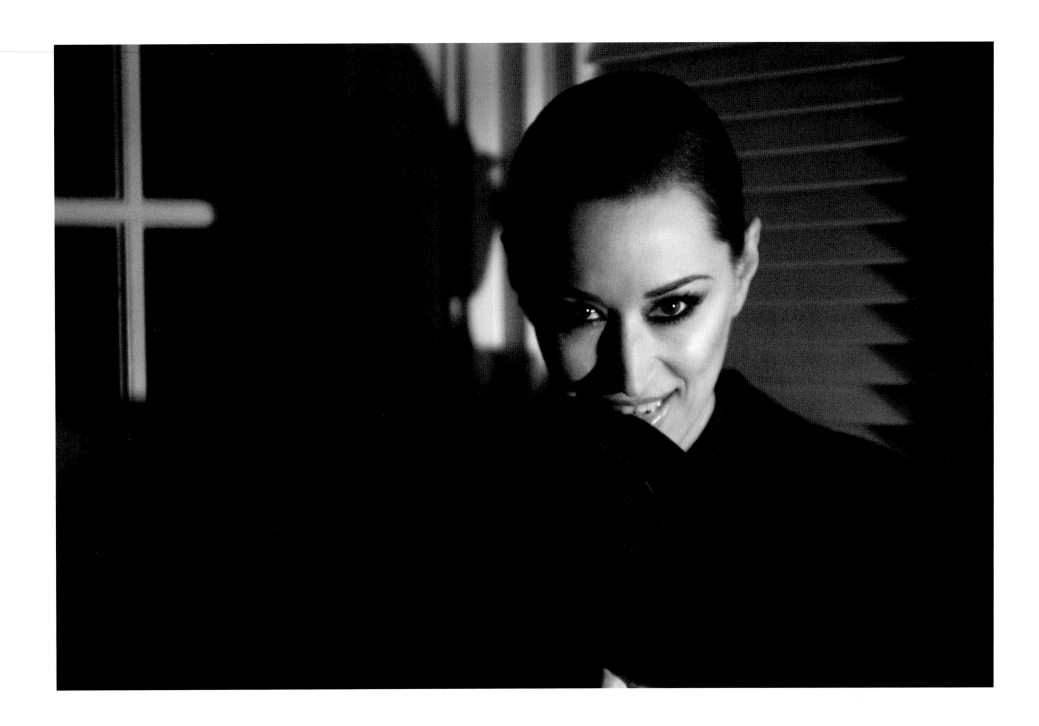

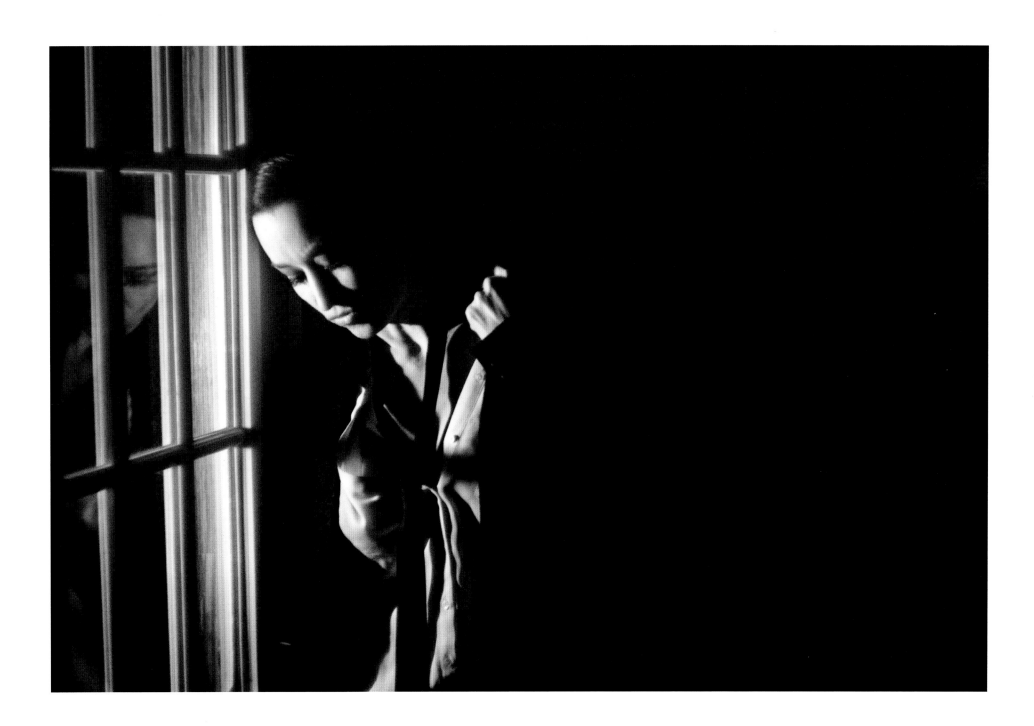

GLORIA STEINEM In 1963 Gloria Steinem played a pivotal role in bringing awareness to social discrimination and injustice through her groundbreaking article, "A Bunny's Tale." Steinem went undercover as a Playboy Bunny at the New York Playboy Club to shed light on the unbalanced power dynamics between the sexes. Amid the social structures of the time, this daring article caused widespread controversy. Critics came from both sides of the aisle to challenge her credibility and beliefs. She was pigeonholed and ostracized. Years passed before she was hired to write another assignment. She was determined to work at exposing and challenging social realities. Steinem's actions and perseverance have had a direct impact on our individual and collective lives on a global scale; her advocacy continues to make important contributions that secure her a place in history as an iconic spokesperson for the feminist movement and equality issues.

I chose to depict this early event in her journalistic career, one that has always inspired me personally, because it was a pivotal moment in the timeline of her accomplishments—a crucial act that can inspire all of us to develop our own strong and persistent voice despite the obstacles we may face.

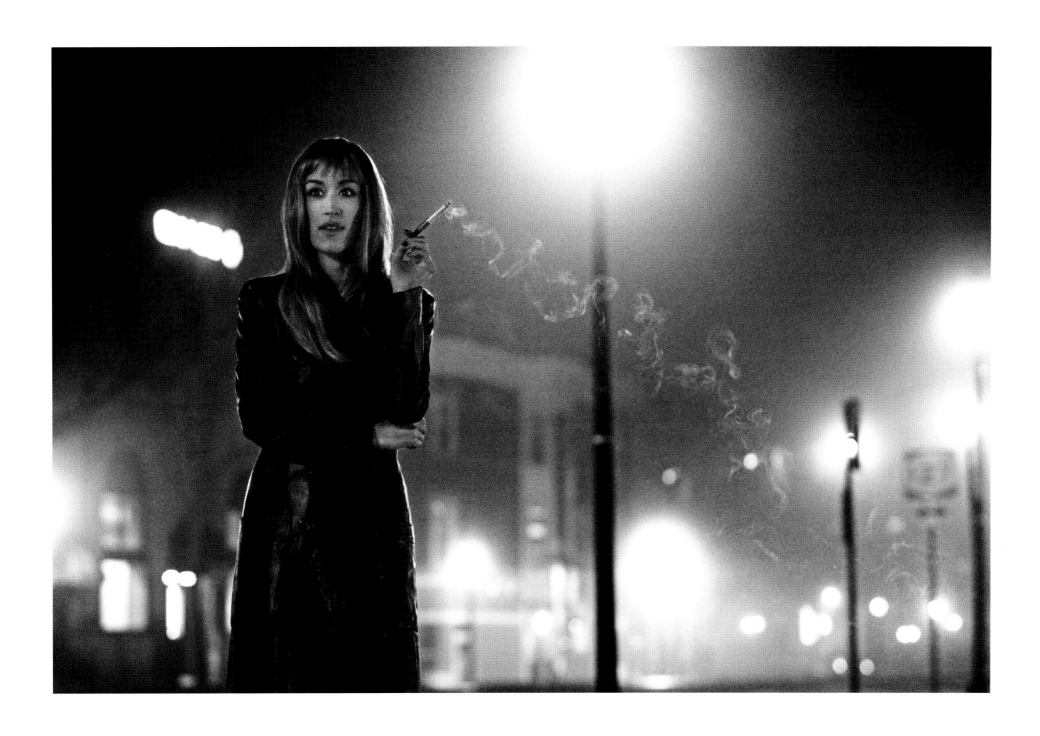

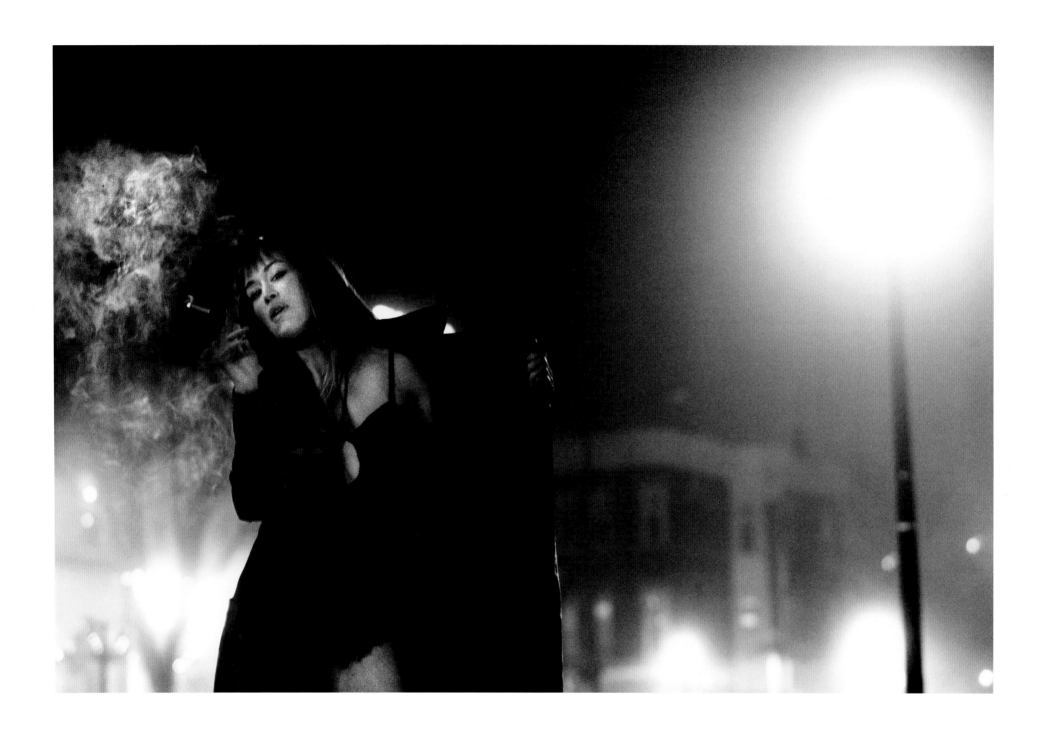

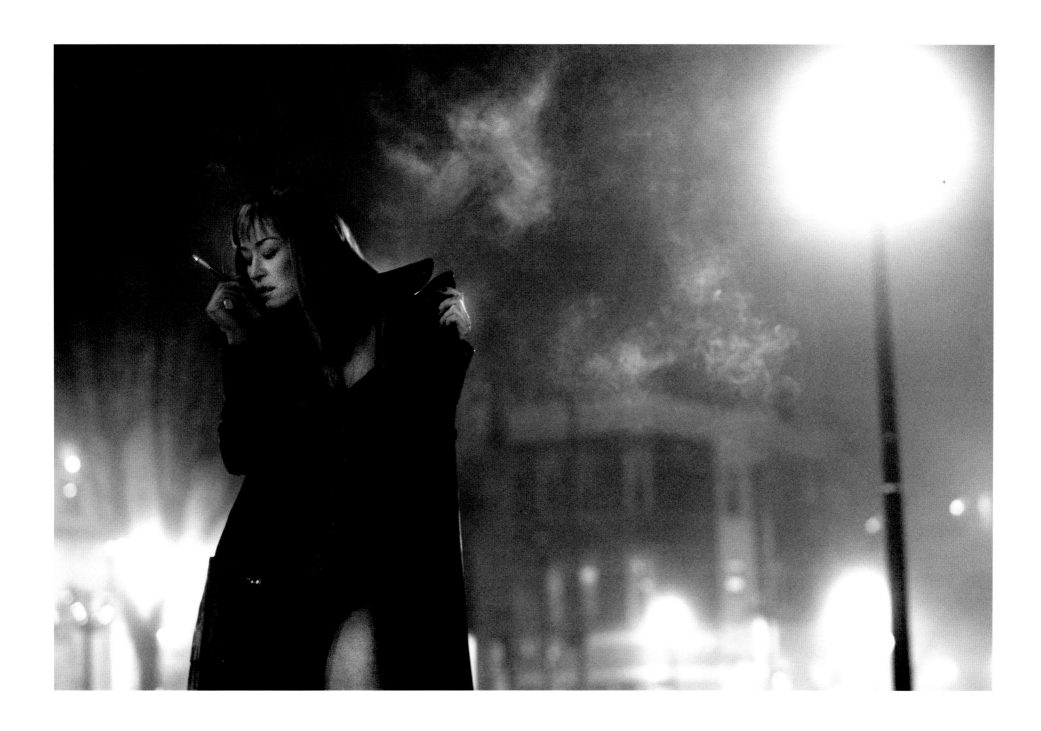

BARBIE The Barbie doll fueled my unlimited imagination. She allowed me to envision and explore grown-up experiences. My favorite Barbie worked overtime to depict a myriad of possibilities, which included multiple careers, a full social calendar, world travel, and, when so inclined, the perfect man. She was smart, beautiful, accomplished, and of course, she could dress for any occasion. Even when running mundane errands, my Barbie's make-believe life was a happy journey filled with exploration and discovery.

As a young girl, I anticipated big-person privileges and responsibilities with awe and excitement. Being a grown-up was going to be so much fun. Yet, as I aged, my sense of play and wonder made a seamless transition into a new reality. My adult existence necessitated navigating life's layered complexities with the added challenges of physical and emotional survival. Because of the gravitational pull of serious life, I make a concerted effort to awaken the child within, not only for myself, but also for those around me. If we don't take the initiative to make the magic happen even in the smallest of ways, we miss out on the fullest potential of life's miracles. I enjoy creating and instigating transformative experiences at home or at work that activate a sense of play and joy, reminding me that I am living my childhood dreams just by the mere fact that I am, indeed, a grown-up.

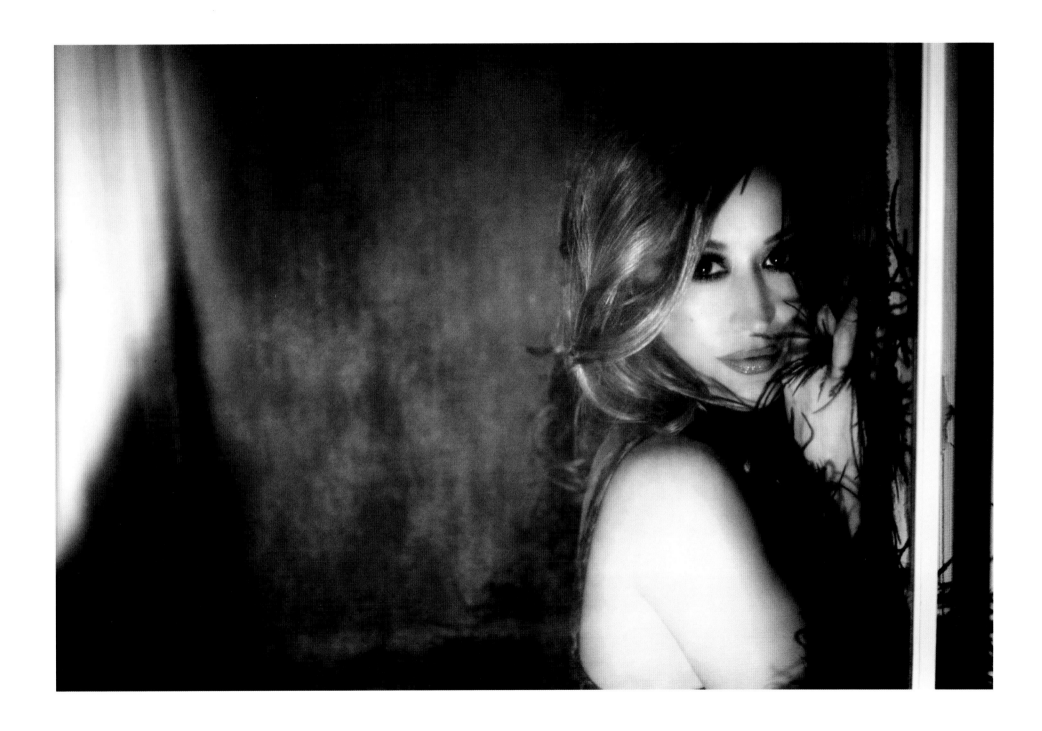

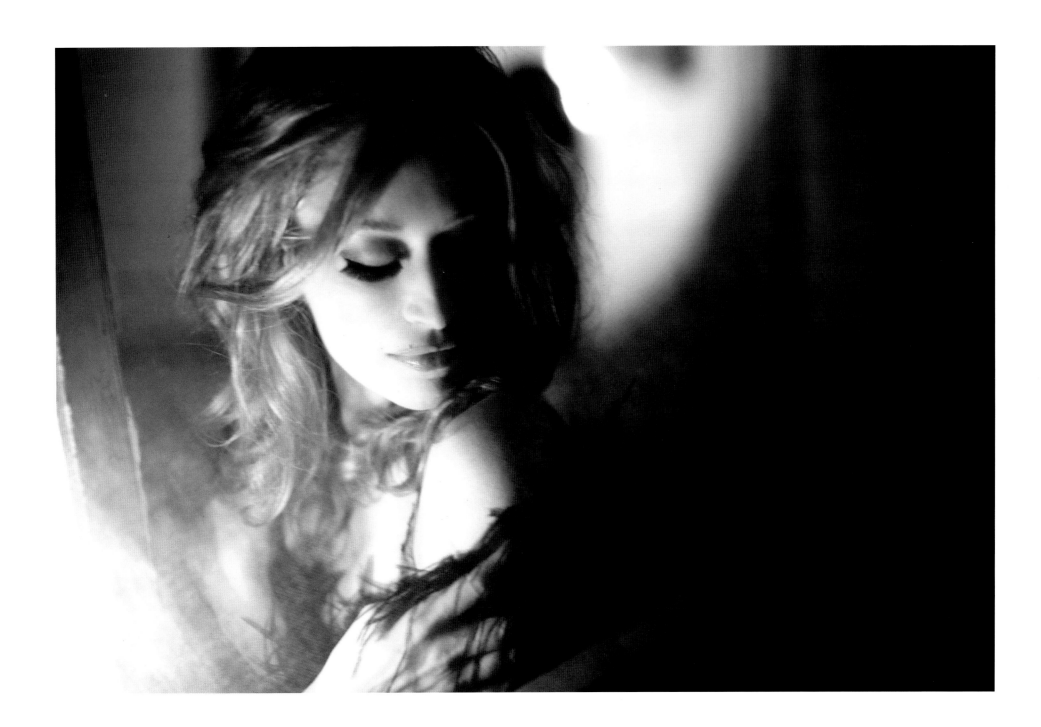

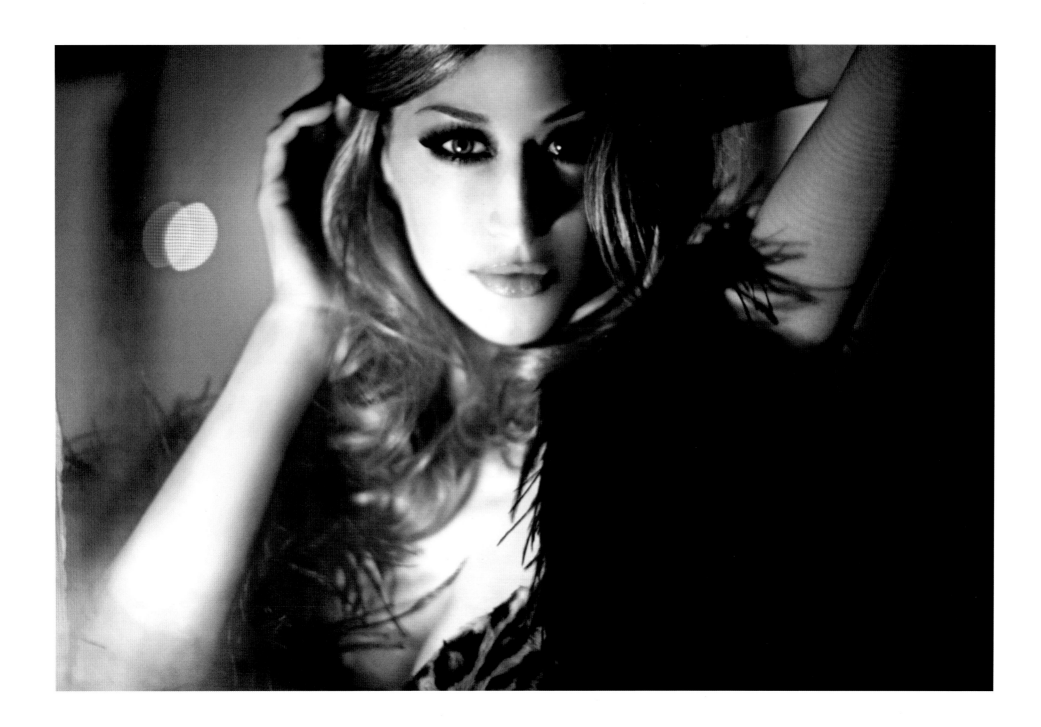

MY MOTHER My mother is a sanctuary. With the inherent power of Mother Nature, she nurtures and sustains all living things around her. Like a faerie queen, she is a source of light and unconditional love for all that live within the embrace of her enchanted realm. She is both as innocent and pure as a fairytale and as wise and knowing as the universe itself. Her tread is humble and gentle. Her influence is great. Tended daily by her heart and hand, her garden is curated and cultivated to provide food and shelter for the creatures within. Raccoons, cats, birds, bunnies, squirrels, and way too many spiders thrive under her care.

Much like the wildlife she fosters, my mother provided me with a nurturing home. She encouraged me to find my wings and take flight from her nest into a world of my own making. Without judgment or an agenda, she supports my choices and my individuality. Regardless of what happens in my life, she lets me know that there is always a place in her home for me to land.

Her love is the supreme gift of my life.

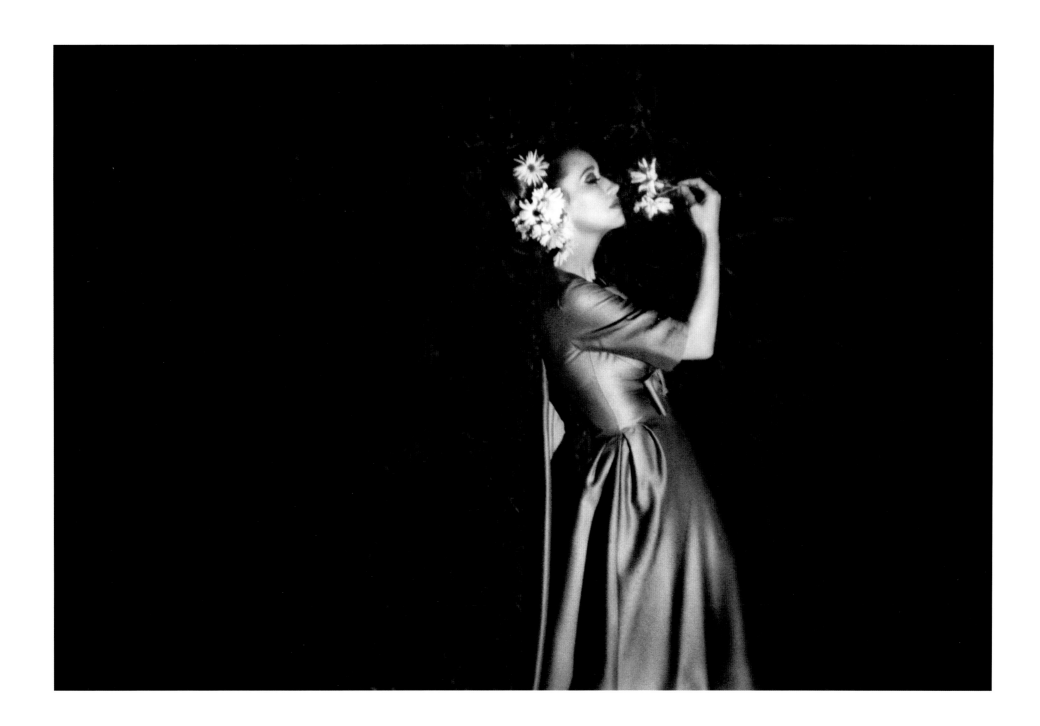

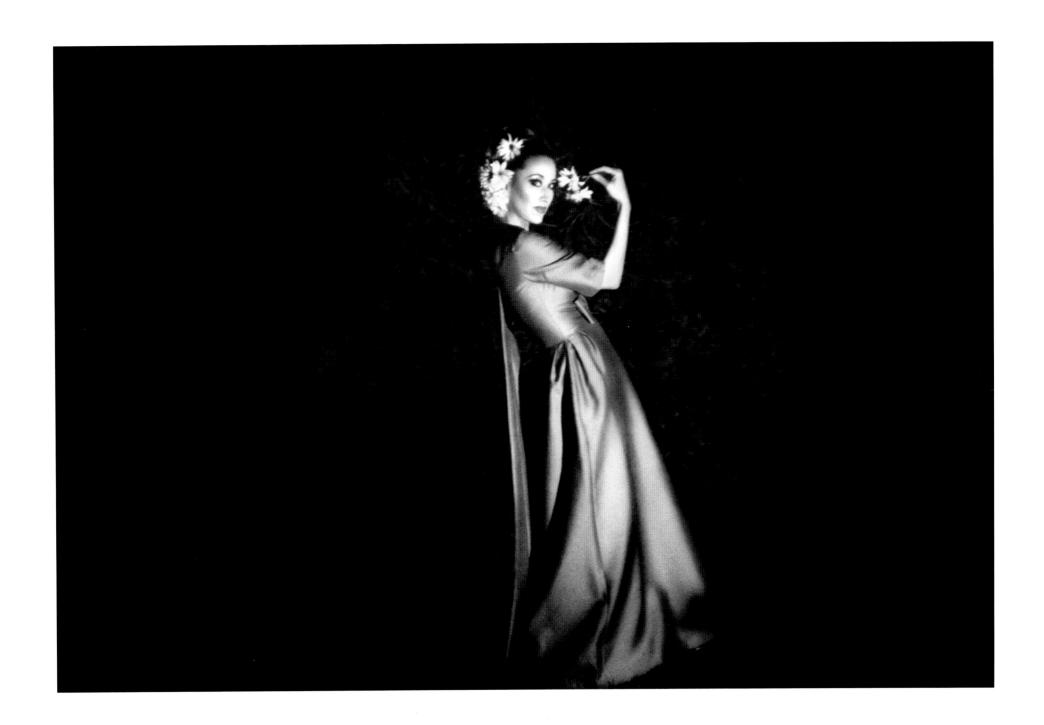

AUDREY HEPBURN Audrey Hepburn defines my feminine ideal. Not only for her extraordinary elegance, mesmerizing beauty, and iconic style, but more notably for the woman she was within. Her sense of self and her priorities were ever in alignment with her compassionate nature. Despite enduring malnutrition and near starvation as a young girl during the Nazi occupation of the Netherlands in World War II, Hepburn never gave up her faith in humanity. She demonstrated this by dedicating herself to being a hands-on humanitarian, devoting her life to helping children in need all over the world as a UNICEF Goodwill Ambassador. While most people know her for her classic Hollywood movie roles, I know her as a symbol of hope.

Hepburn possessed a humble grace throughout her personal and public life. Instead of being defeated by strife, she braved her hardships virtuously. In this process she unearthed the wisdom, saw the beauty, and kept a sense of humor in all experiences that she faced. By her example, Audrey Hepburn has shown me that it is possible to live life's full spectrum of dark and light with unwavering dignity and goodness, and to be able to conclude one's time on earth with one's spirit intact.

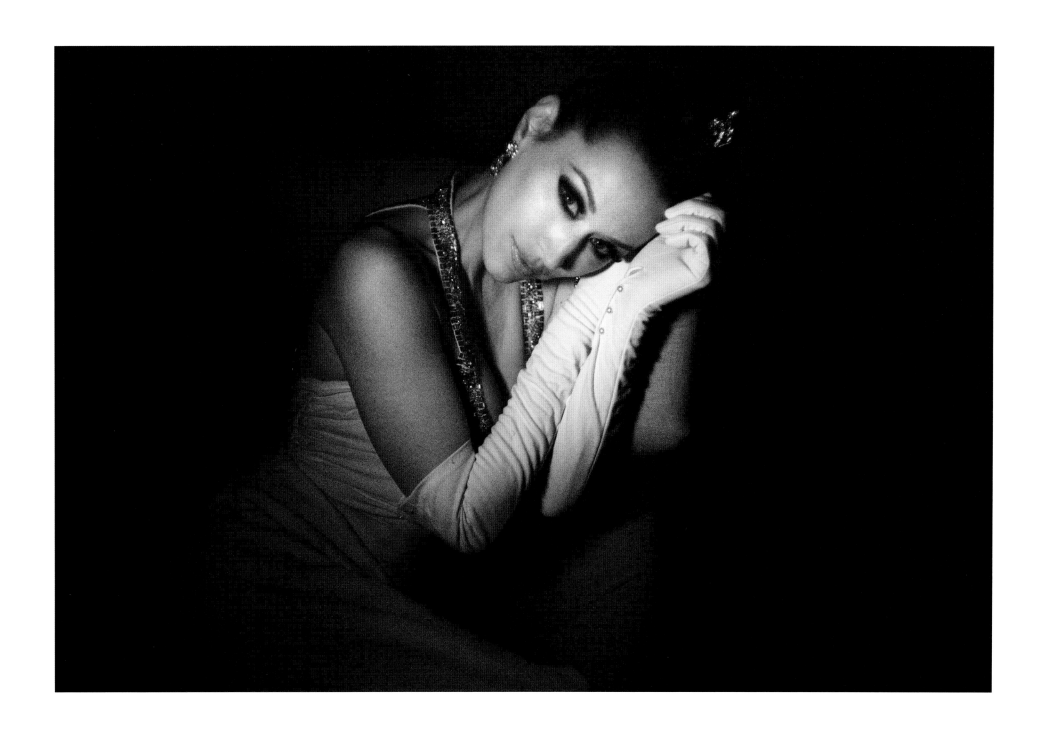

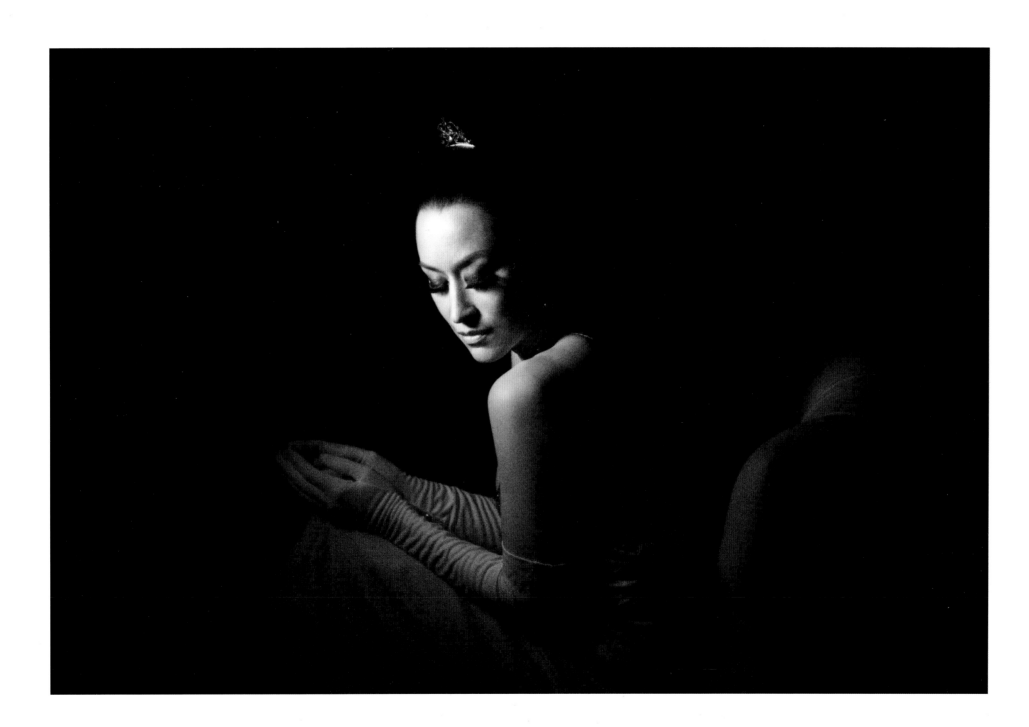

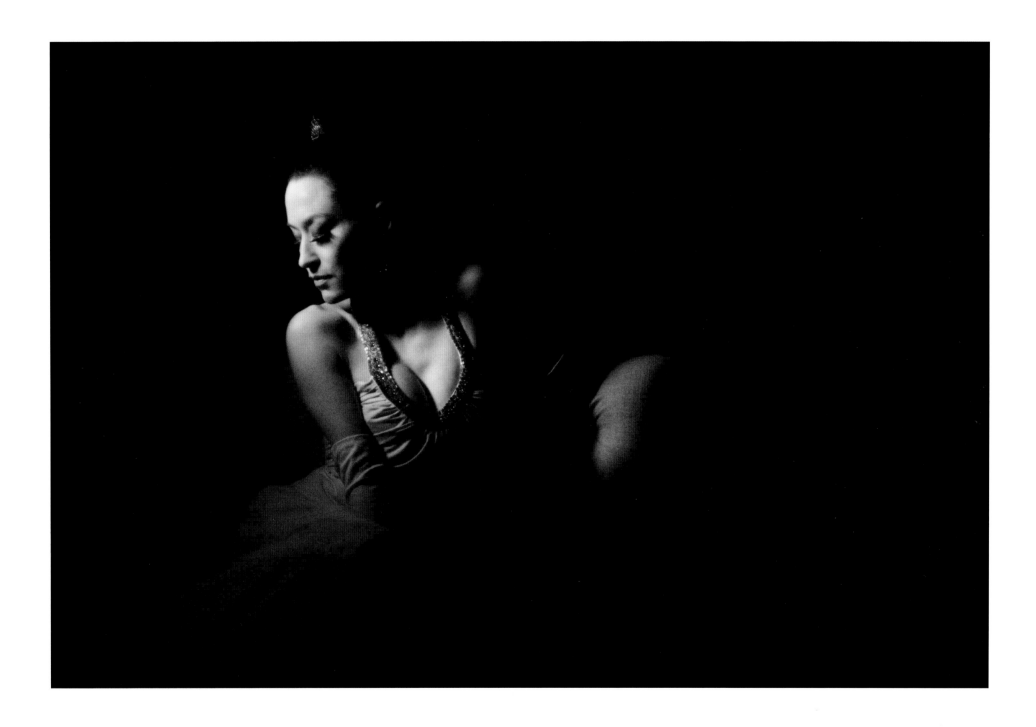

SPIRITUAL GUIDES An ode to the spiritual energies in my life who are my chaperons on this side of the veil and beyond. They are always present and take on many forms to deliver their guidance and support. Some come in loud and clear—living beings that trumpet in to make their significance known. Others suggest a sound as delicate as vapor, a fleeting intuition that will be lost if I do not stop in that very moment to carefully tune in to their messages.

Regardless of their style or approach, I am grateful for their omnipresence, for they are the deepest center of my stability—and the very backbone of my endurance.

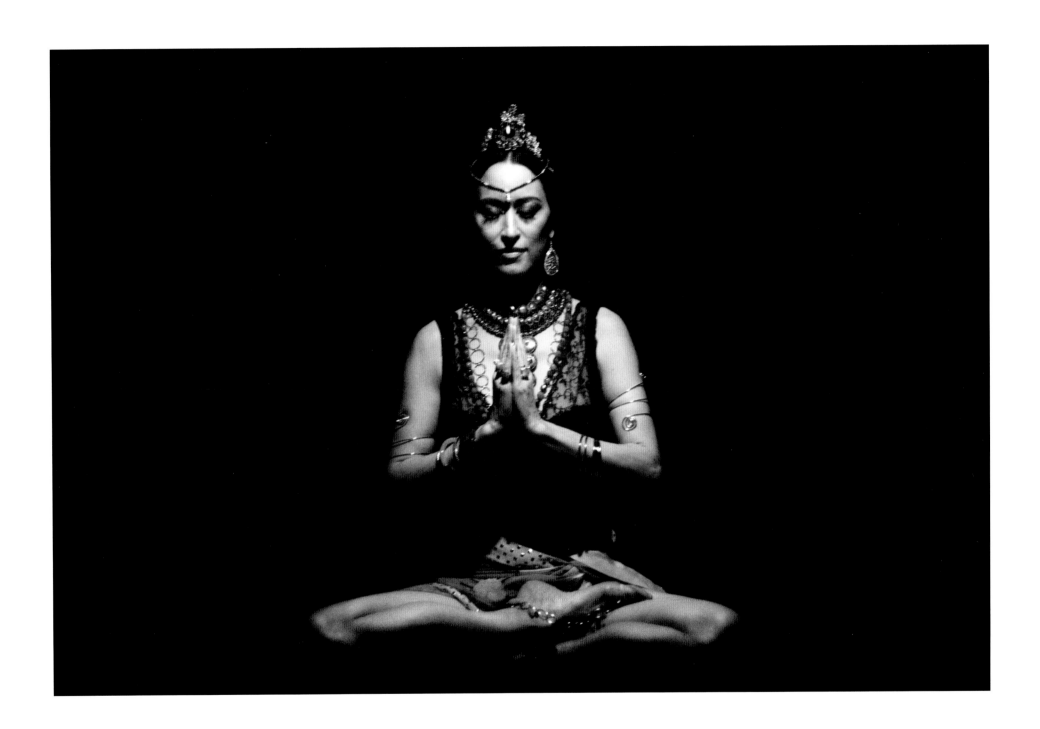

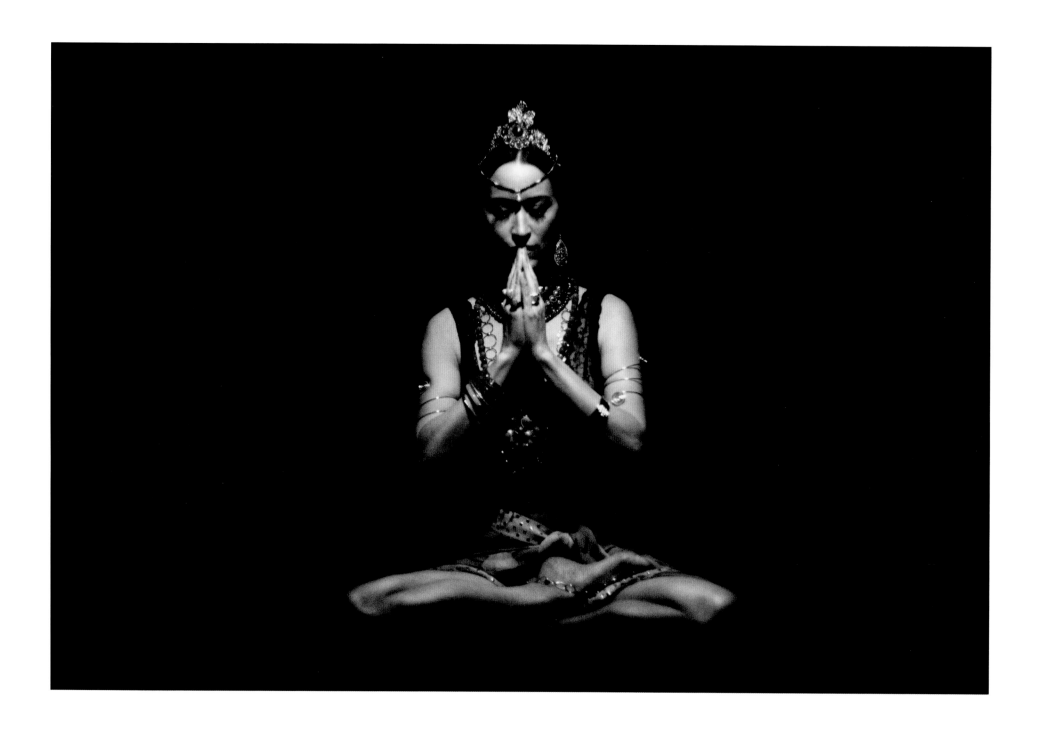

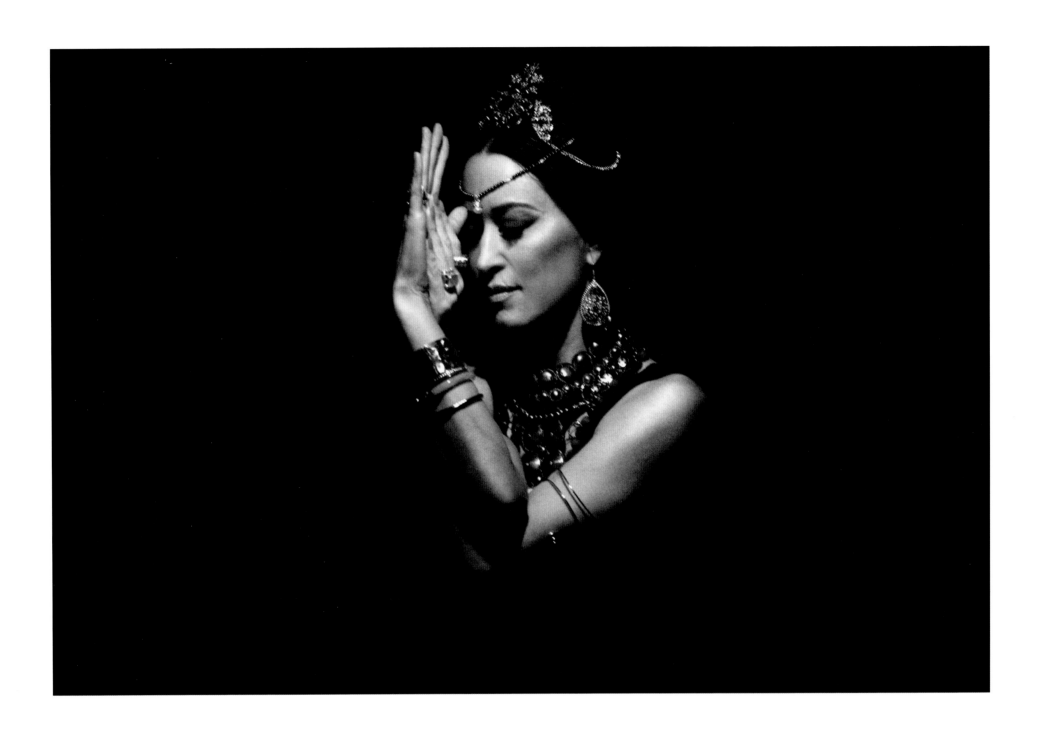

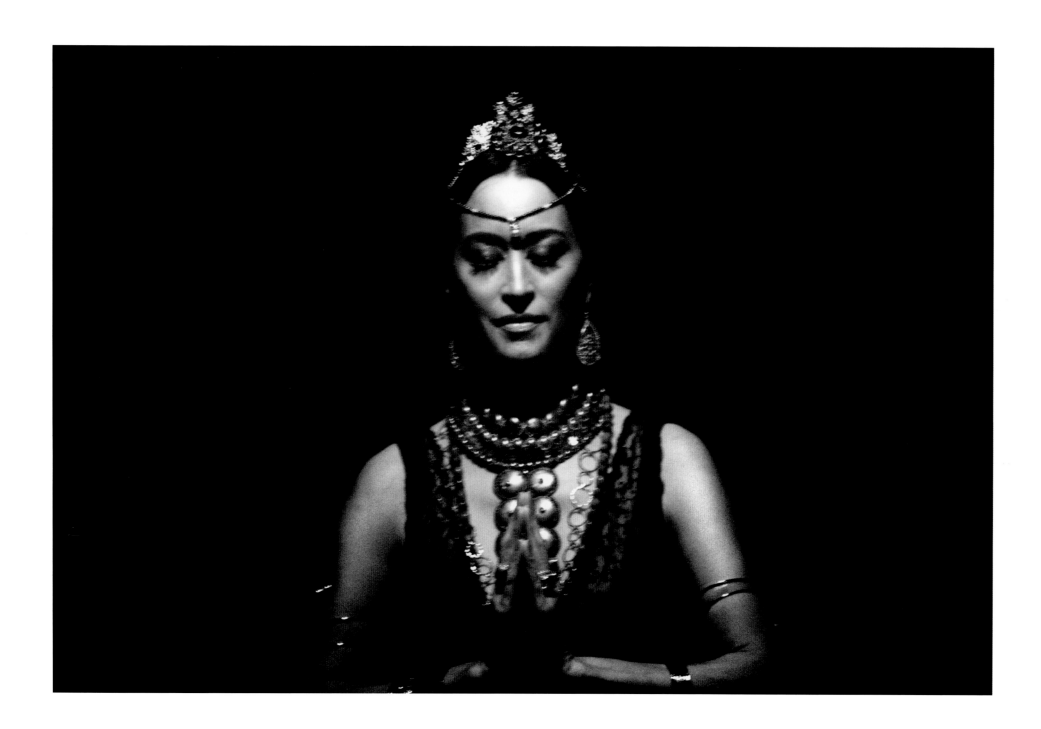

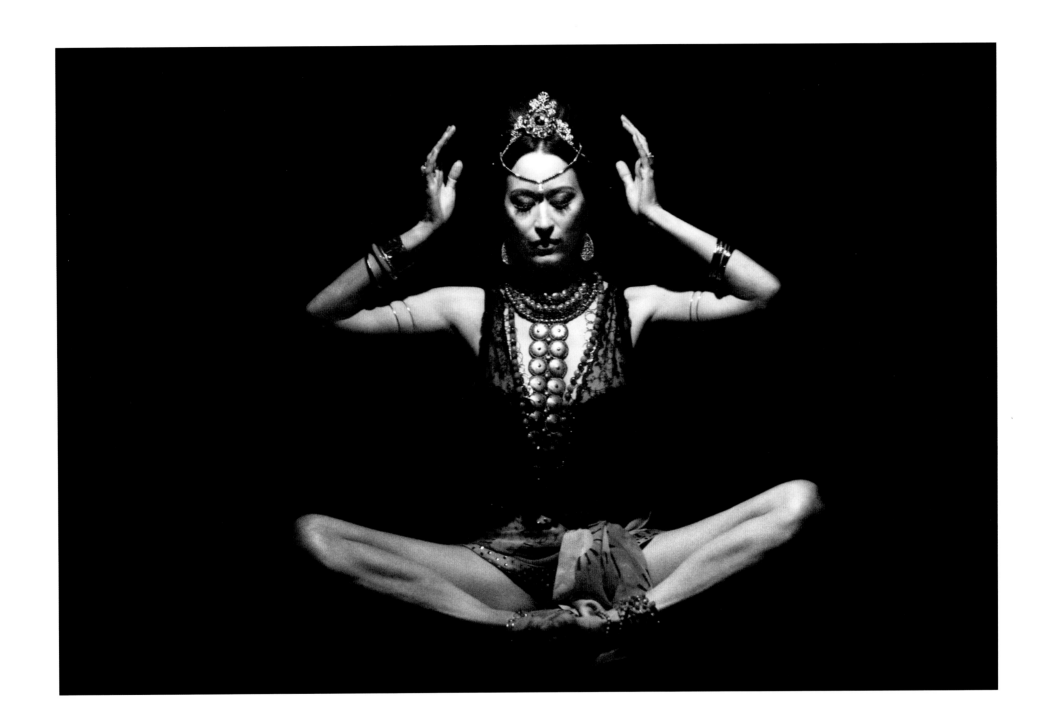

REBIRTH Now that I have reached my middle ages, I am experiencing rebirth. As I enter a new stage of my growth as a woman, I no longer feel youth's uneasiness or the obligation to reach my self-imposed potential. From this vista, I have a different perspective. I can see where the culmination of my choices and experiences has brought me. And I am content and grateful to be whatever my life has made me.

To be clear, I did not accomplish many of the personal or professional objectives that my youthful expectations set out for. The journey I took was an unpredictable path filled with challenges, obstacles, and unexpected twists and turns. One foot in front of the other, I made my way, albeit sometimes slower than a snail's pace. I ended up somewhere other than where I thought my journey would take me. Somewhere much, much better. And here I discover that the ambitions of my youth no longer motivate my steps. I fancy a simpler life where I can be attentive to each moment. I am being, not doing.

As I reflect upon how I got here, I am ever thankful to the many people who have imbued my life with inspiration. I am them. I am me. We are one woman.

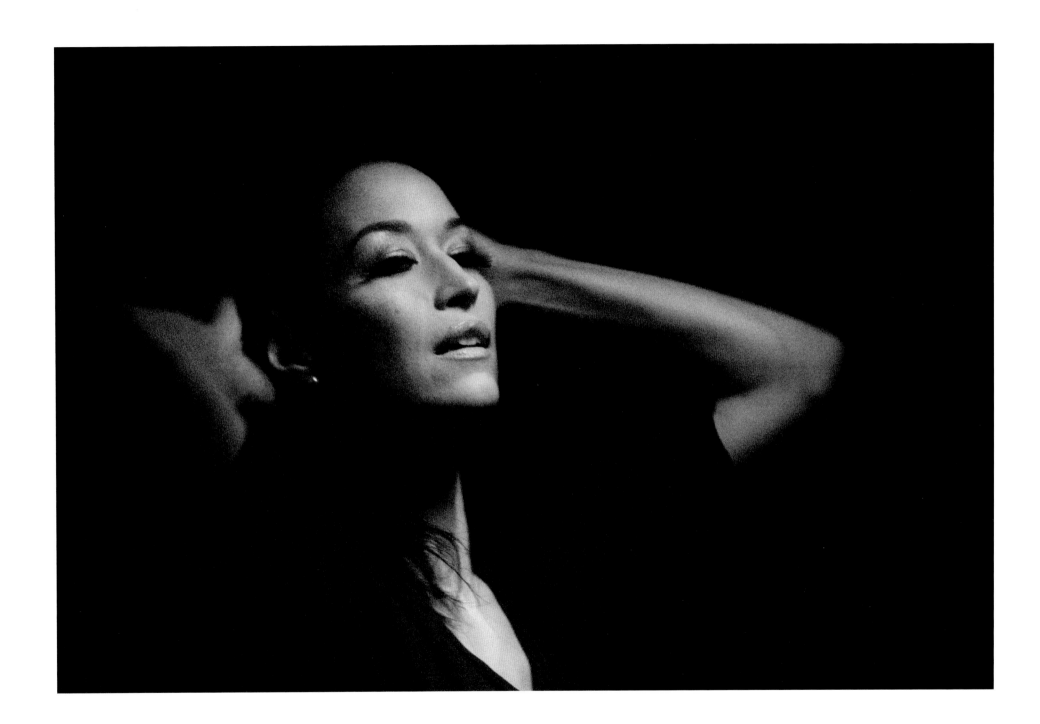

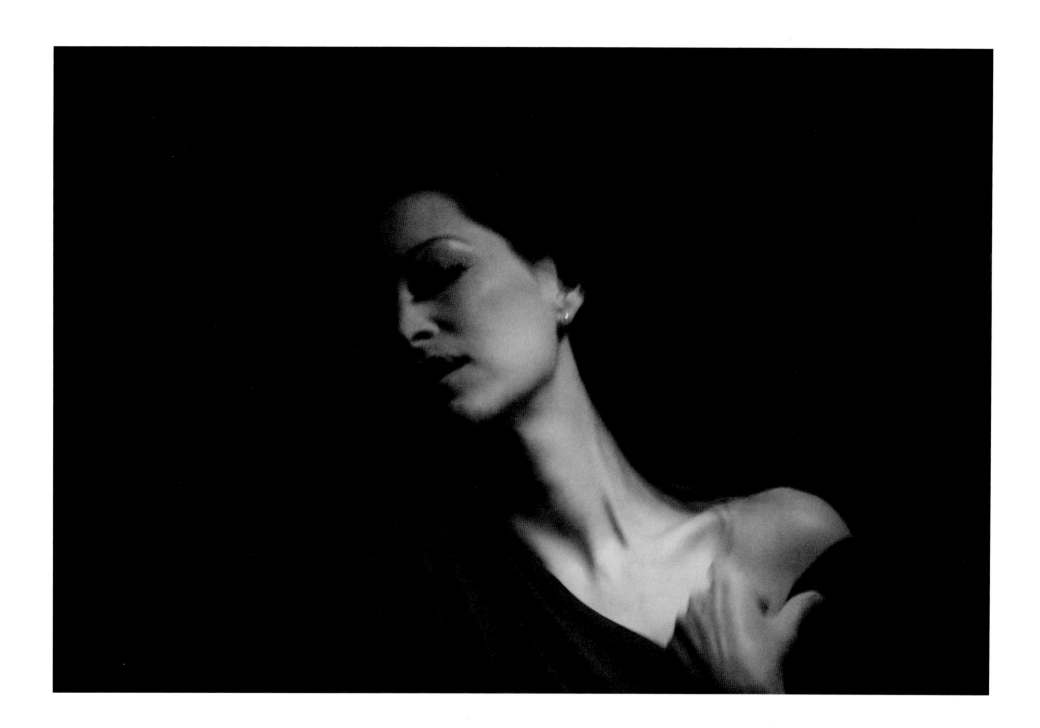

PART TWO: JOHN'S TAKE

In the four decades that photography has been an extension of my mind, body, and soul, the *One Woman* project is probably the most interesting body of work I have ever photographed and, in some ways, the most challenging.

My most important and historic body of work, *Aftermath: Unseen 9/11 Photos by a New York City Cop*, had its share of challenges. Amid ash and smoke and with limited visibility, I had to address many decisions before I would fire my shutter. It was a sensitive and labor-intensive pursuit. Photographically, however, I had a clear understanding of what I was dealing with.

For me, the most difficult aspect of being a photographer is not knowing what type of work or visual genre will inspire my next body of work. Because I am not the snapshooter type, I am unable to seek it out by strapping on a camera and going out in search of it. I am also not able to brainstorm in order to conjure a subject matter. The more I think, the more elusive it becomes. A body of work or a subject matter has to call out to me. Such was the case with *One Woman*. It must be an organic encounter that just comes to me. When I get that hit, I can immediately feel and see most, if not all, of my images.

Each time I acquire an optic, whether current or vintage, my first priority is to run it through its paces based on my shooting style and look for the qualities I expect from that particular lens. In the past I had always done these tests on film. With the advent of digital photography, however, I am able to set the parameters on the camera so that it behaves as analog as possible. For this body of work I chose the Leica M Monochrom, the first digital camera designed to shoot solely in black and white.

This would be the first time I would capture a body of images completely on the digital format.

Out of curiosity I compared film samples to an equivalent digital image of the same subject to see how much of an analog feel the Monochrom sensor gave the final image. I was impressed: the Monochrom sensor not only behaved in a very analog manner, but it also added its own unique feel to the image. It was exciting to see where this first-time journey in a different format would take me.

One evening I decided to test a Leica medium-length portrait lens using my Monochrom camera. I asked Elicia to pose next to a very low-watt desk lamp and fired off fifteen to twenty frames before I stopped to look at the sequence. As I reviewed the images, Elicia began to discuss her lifelong dream of being photographed portraying the many female personalities that have had a profound effect on shaping the woman she has become.

At that moment I didn't fully absorb the magnitude of her dream but agreed to help realize her vision. A few days passed before she asked if I was in the mood to shoot. It was around 10:30 p.m., which turned out to be earlier than we'd shoot most of the other sessions. I agreed, and she went to get ready. An hour passed, and I realized that I had no idea what I was going to be shooting.

I dozed off, and another hour later I was quietly awakened by a woman dressed from an era forty years before I was born. I was staring at a woman I did not know. Consciously I knew it was Elicia, but my eyes and subconscious saw an entirely different person. It was then that I made the decision to treat all the women Elicia was to portray as exactly that—as women unknown to me, each of whom I was meeting for the first time.

Approaching this as if I were shooting Elicia in a costume would have blurred the line between reality and portrayal. My reality was the portrayal—I had never in my life met

any of the successive women who would stand before me. It was the first time in my photographic career that I had viewed a subject in this manner. In most cases I had always known who or what I was going to photograph, or had a clear idea of what I wanted to photograph. This new and uncharacteristic approach was unconscious. It didn't register with me initially. When I did realize it, I went with the flow and didn't question it. I took in each persona at the moment she was presented to me. It was then—and only then—the locations, lens choices, and lighting came together to reveal her through my camera. And as the session progressed, Elicia conducted herself in the same way with me. We—each new persona and I—would build our relationship over the span of each session.

Our sessions were very quiet and intimate. There was no music, and the shooting always took place late at night. We could barely see each other. All the lights were off except the one I was shooting with. It was only the two of us in the world of Elicia's

portrayals. She never questioned my subtle commands or my shooting style, or what would come of it. There was very little verbal interaction—the result of complete trust between two people.

At the end of each session we slowly reverted back to our reality. As a stylist and makeup artist, Elicia retreated to her space to undo her portrayal, which sometimes took longer than it did for her to get ready. After cleaning up and before settling in for the night, we'd use Elicia's laptop to quickly check what I had shot. I always noticed how many frames I photographed. Since I had shot digital, it would have been easy to fall into the "spray and pray" category of firing off five hundred frames unnecessarily. I was happy to find that I had stayed within a digital frame count that would have been the equivalent to my target range of four to seven rolls had I been working in my usual thirty-six exposure film format.

This collaboration has been a fulfilling creative journey. It was a joy to share Elicia's passion for the project and to help realize her vision.

APPENDICES

IMAGE INDEX

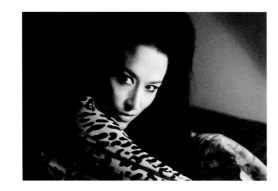

Page 11: *Untitled No. 0088*

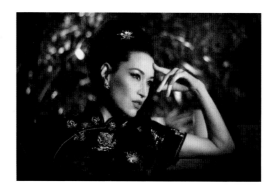

Page 19: *Untitled No. 0776*

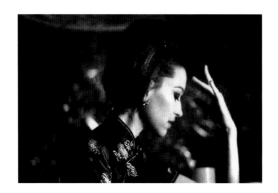

Page 17: *Untitled No. 0703*

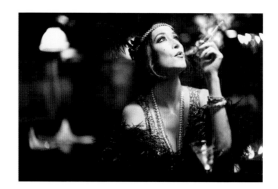

Page 23: *Untitled No. 0944*

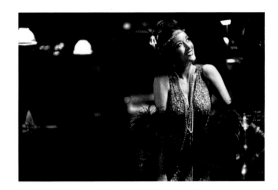

Page 24: *Untitled No. 1014*

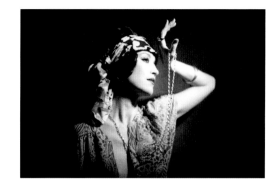

Page 31: *Untitled No. 1231*

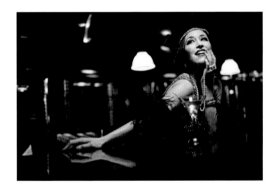

Page 25: *Untitled No. 0898*

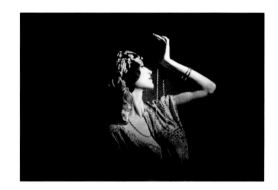

Page 33: *Untitled No. 1207*

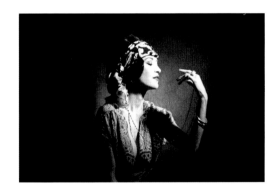

Page 29: *Untitled No. 1191*

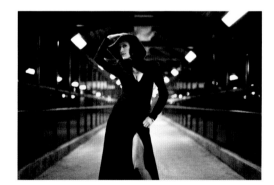

Page 37: *Untitled No. 0394*

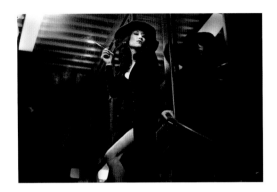

Page 39: *Untitled No. 0383*

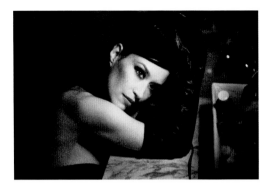

Page 47: *Untitled No. 0472*

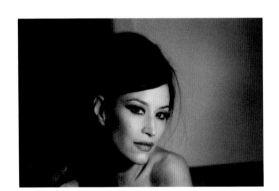

Page 43: *Untitled No. 0389*

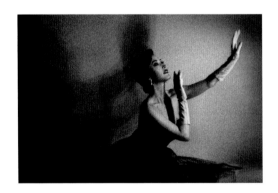

Page 51: *Untitled No. 1426*

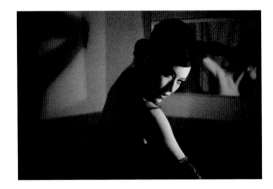

Page 45: *Untitled No. 0432*

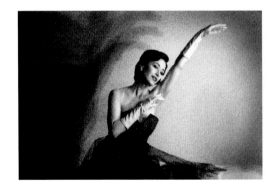

Page 53: *Untitled No. 1410*

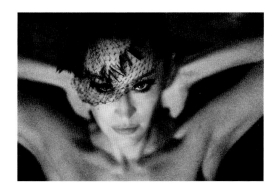

Page 57: *Untitled No. 0274*

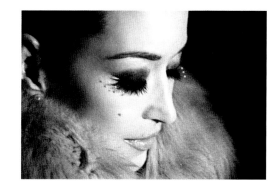

Page 65: *Untitled No. 0125*

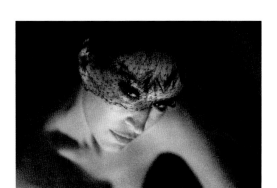

Page 59: *Untitled No. 0280*

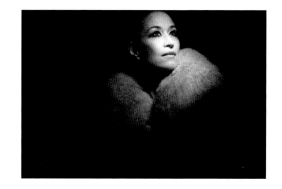

Page 67: *Untitled No. 0222*

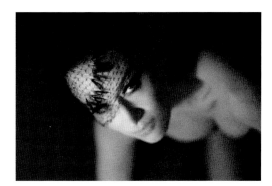

Page 61: *Untitled No. 0308*

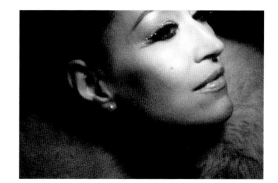

Page 69: *Untitled No. 0200*

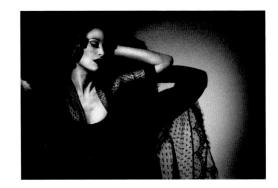

Page 73: *Untitled No. 0864*

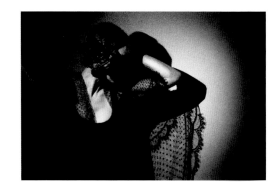

Page 77: *Untitled No. 0875*

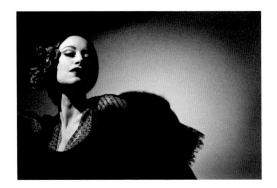

Page 75: *Untitled No. 0906*

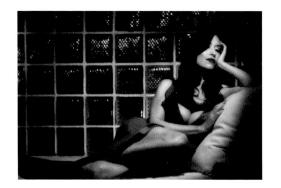

Page 81: *Untitled No. 1560*

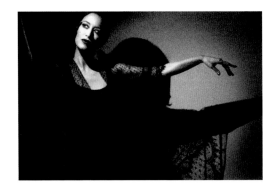

Page 76: *Untitled No. 0898*

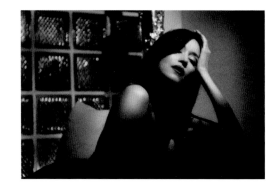

Page 83: *Untitled No. 1538*

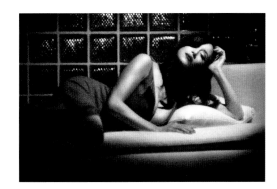

Page 85: *Untitled No. 1583*

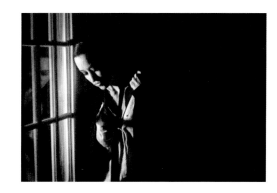

Page 93: *Untitled No. 1030*

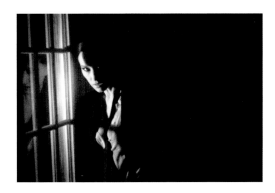

Page 89: *Untitled No. 1039*

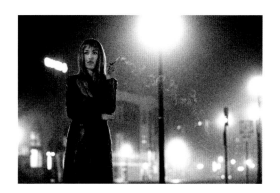

Page 97: *Untitled No. 0907*

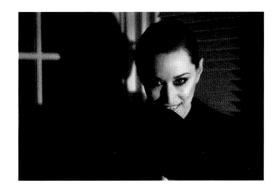

Page 91: *Untitled No. 1009*

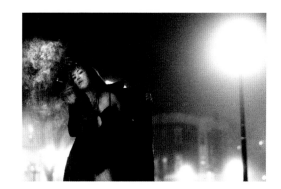

Page 98: *Untitled No. 0919*

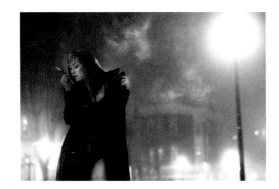

Page 99: *Untitled No. 0924*

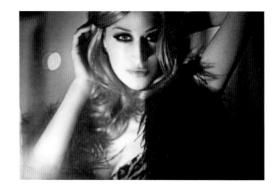

Page 107: *Untitled No. 0788*

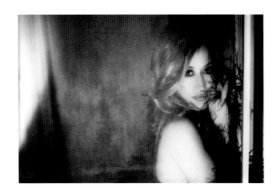

Page 103: *Untitled No. 0837*

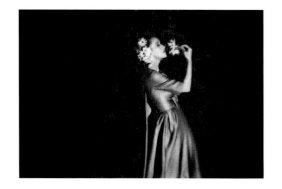

Page 111: *Untitled No. 1331*

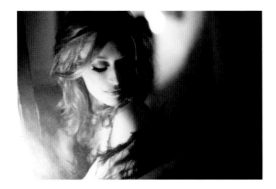

Page 105: *Untitled No. 0806*

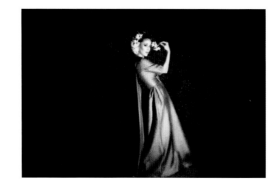

Page 113: *Untitled No. 1341*

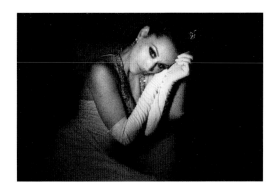

Page 117: *Untitled No. 1045*

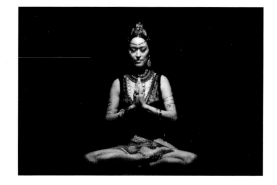

Page 125: *Untitled No. 1106*

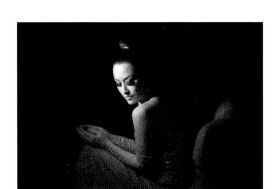

Page 119: *Untitled No. 1049*

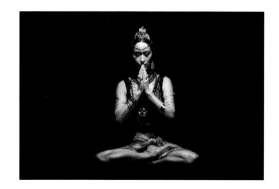

Page 126: *Untitled No. 1138*

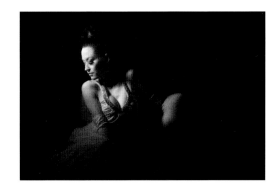

Page 121: *Untitled No. 1022*

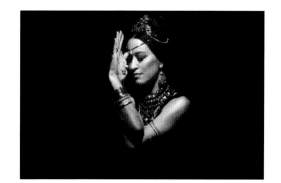

Page 127: *Untitled No. 1211*

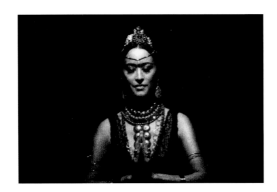

Page 128: *Untitled No. 1224*

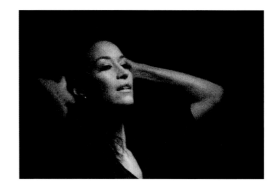

Page 133: *Untitled No. 0235*

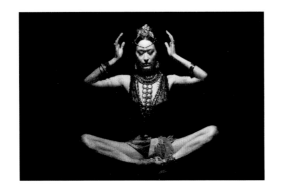

Page 129: *Untitled No. 1180*

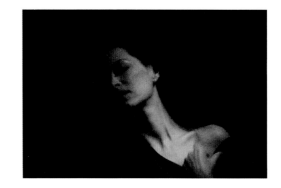

Page 135: *Untitled No. 0250*

About the Author

ELICIA HO

Elicia Ho was invited at the age of fifteen to join The School of American Ballet in New York City. A professional ballet dancer for twenty years, she trained with celebrated artists and teachers, including Alexandra Danilova, Stanley Williams, Suki Schorer, Kay Mazzo, and Antonia Tumkovsky. Throughout her ballet career, Ho danced principal roles for companies, such as the American Repertory Ballet under the artistic direction of Septime Webre.

For more than thirty years, Ho has worked as a professional makeup artist with models, politicians, newscasters, sports figures, actors, and musicians. Her notable clients have included Billy Joel, Vera Wang, and Diane Sawyer. She has also worked as an interior decorator on residential and commercial projects in New York City.

She is currently working on a book inspired by her longtime practice of meditation.

Born in Seattle, Washington, Ho currently lives in Seattle, Washington, and Harrison, New York.

About the Photographer
JOHN BOTTE

John Botte is a former NYPD second-grade detective and lifelong photographer, whose work has appeared in exhibitions internationally. Born in New York to Italian parents, he spent part of his youth growing up in Italy on his grandfather's vineyard. Photography found Botte at the age of eight, when his uncle gave him a 110 camera that had come free with two packs of cigarettes. At age twelve, he was taken under the wing of a master black-and-white, fine-art printer, who mentored him and exposed him to the works of photographers such as Slim Aarons, Lisl Steiner, and Barbara Morgan.

Since his teens, Botte has spent his free time photographing concerts and bands. Known for his distinctive black-and-white style, he was hired by *Rolling Stone* magazine to photograph Bruce Springsteen, Van Halen, AC/DC, and Steve Miller, among others.

Botte is best known for his work documenting the aftermath of September 11, 2001, at the site of the World Trade Center in Manhattan. His position as a first responder and experienced detective gave him the access that allowed him to capture the iconic and profound images of a pivotal moment in history. Botte spent countless hours at Ground Zero, photographing and witnessing firsthand the heroic, behind-the-scenes rescue and recovery efforts.

He is the author of *Aftermath: Unseen 9/11 Photos by a New York City Cop* (Harper Collins) and *John Botte: The 9/11 Photographs, 10th Anniversary Exhibition Folio* (Morrison Gallery).

Botte lives in Seattle, Washington, and Harrison, New York.

Acknowledgments

This book would not exist without the following individuals, who have invaluably contributed their specialized talents and generous hearts. For their artful insights, and boundless support and encouragement, they will forever have our deepest respect and gratitude.

Joan Brookbank, Dr. Brian Mignola, Chuck Keogh, Nina Scherenberg, Shanley Miller, Elizabeth Choi, Dean Vivolo, Marta Hallett, Brandon Schultz, Conor Romack, Gabrielle Schecker, and Liz Trovato.

Always, our heartfelt thanks and acknowledgments to—

Giustina Botte, Pasquale Botte, Phil Federici, Michael Botte, Frank Botte, Roseann Giglio, Sal Giglio, Alex Giglio, Ryan Giglio, Leslie Ho, Franklin Ho, Carol Miller, Marcus Ho, Elaina Davis, Sofia Ho, Josh Lehrer, David Farkas, Frank Wilhelm, Chibba, Adam Goodstein, Sam Alfano, Stefan Daniel, Bjoern Dietzler, Doc Cohen, Karen Steinberg, Glenn Evans, Stephen Gandy, Grace Romagnoli, Joe Sorrentino, Michael Barasch, Noah Kushlefsky, Roger Horn, Walter Leica, Sherry Krauter, Laura Hughes, Lorrie Caplan, Stephen Shern, Anne Rogers, Paul Cox, Dylan Cox, Maria Derr, Janet Duran, Maria McDonald, Mac McDonald, Isabel McDonald, Maureen Grady, Jane and Ariel Fox, Pam Sommers, Sara Roberts, Nickey, Pepper, and Mei Mei.

To those depicted in this book—thank you for the inspiration.